THE
Archive Photographs
SERIES

NEWHAM
DOCKLAND

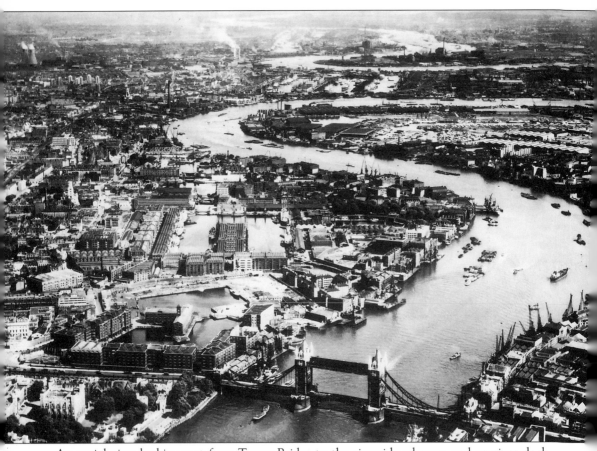

An aerial view looking east from Tower Bridge to the riverside wharves and up river dock systems of the Port of London Authority in 1961. In the foreground St. Katharine's Dock, London Dock just beyond, Surrey Commercial Docks on the south side of the river. West India and Millwall Docks on the Isle of Dogs and the Royal Docks in the distance.

Cover photograph: Smithfield Market strikers being addressed by one of their representatives at the entrance to the Royal Victoria Dock on 6 February 1936. They had gone there to seek support in their fight for better conditions. (Socialist Worker Photograph Collection)

THE
Archive Photographs
SERIES

NEWHAM
DOCKLAND

Compiled by
Howard Bloch

CHALFORD

First published 1995
Copyright © Howard Bloch, 1995

The Chalford Publishing Company Limited
St Mary's Mill
Chalford
Stroud
Gloucestershire
GL6 8NX

ISBN 0 7524 107 6

Printed in Great Britain by
Redwood Books, Trowbridge, Wiltshire

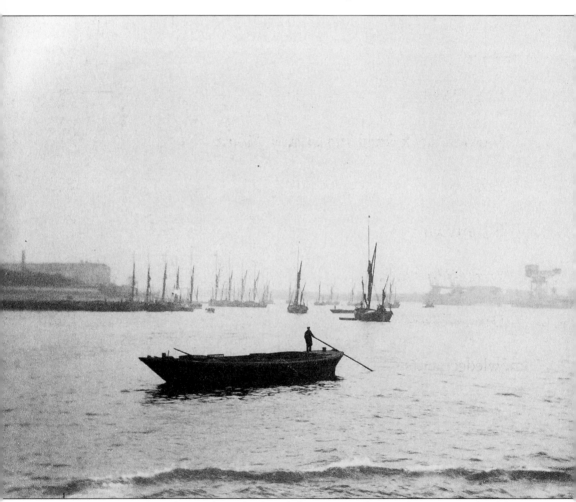

From the vast scale of the Docks to the lone lighterman working under oars on a dumb barge on the river, the Port was an immensely complex operation relying on a large, skilled workforce.

Contents

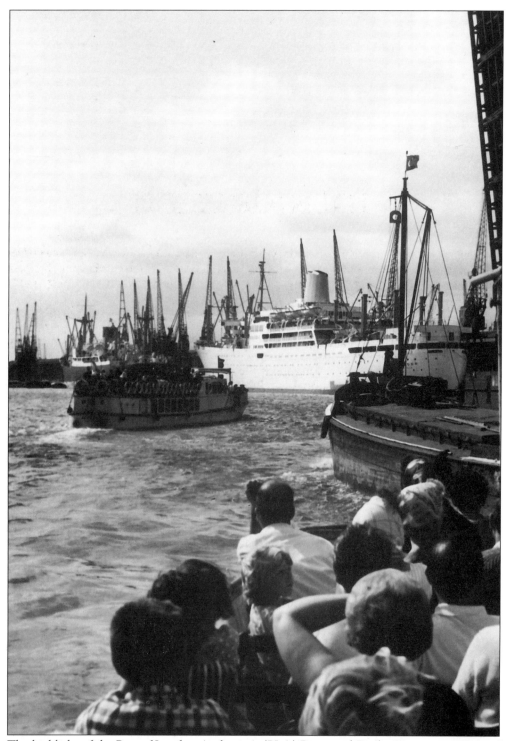

The highlight of the Port of London Authority's (PLA) River and Docks Cruises was a tour of the Royal Docks. On entering the King George V Dock visitors were met by a breathtaking sight. The tour shown here was in 1964.

Introduction

Newham Dockland (an area in the south of the former County Boroughs of West Ham and East Ham) was a little known world, which most people had heard of but few had visited. Focussed around the Royal Group of Docks, which is the largest area of impounded dock water in the world, it was one of Britain's major industrial centres.

From the beginning of the nineteenth century a series of enclosed docks was built in London where ships and their cargoes could be handled and stored in secure conditions. The Victoria Dock was constructed on the Plaistow Marshes and opened in 1855 to accommodate the new steam vessels.

New industries moved into the area along the riverside belt, attracted there by the lack of legislative restrictions on noxious trades and the availability of large sites with river frontage where bulk raw materials could be brought in. Several new towns developed around the major factories Silver's rubber works—Silvertown, Henley's electric telegraph works—North Woolwich and the Gas Light and Coke Company's gas works—Beckton. The opening of the Royal Albert Dock in 1880 accelerated further industrial development.

Hundreds of terraced houses were built to accommodate the growing population which came to the area from throughout Britain and many parts of the world to find work. Amongst those who moved to Silvertown were Irish dockworkers, German chemists and sugar bakers, Scottish sugar workers from Greenock who came down with Lyle's and Lithuanians who had fled from political persecution in Eastern Europe.

Much of the work for both men and women was casual and unemployment and poverty were common. Large crowds of men would gather near the dock gates each day for the 'call' in the hope that they would be chosen for the day or even a few hours work. Many jobs involved heavy manual labour in unhealthy and dangerous conditions and accidents and fatal injuries often occurred. Some workers joined the new trade unions that were formed following the success of the Great Dock Strike in 1889 and won improvements in pay and working conditions through industrial action.

Ships brought seamen, passengers and cargoes from around the world to the Docks. Running the docks was an immensely complex operation which relied on the skills of thousands of people ranging from the dockers, clerks and women ship scrubbers to tobacco samplers and lightermen. The local economy was heavily dependent on the docks and many associated industries and services benefited from their presence including cafes, engineering works and laundries.

Each of the dockland districts had its own complex and distinctive character especially in the period between the Wars. The Victoria Dock Road was one of the most cosmopolitan places in London and bustled with life night and day. There were public houses every few yards and these opened early in the morning to serve the needs of the dockworkers both for refreshment and

information about the work to be had. There were shops, dining rooms and lodging houses run by Indians, Chinese, Jews and Italians, where seamen of all nationalities would be sure of a welcome and assistance in finding somewhere to stay after a long voyage. Off the side streets lived black seamen and their families. Canning Town and Custom House had the largest black population in London in the 1930s.

To the east were the Beckton Marshes on which the Port of London Authority had planned to construct a large new dock to meet its expanding needs. Beckton Gasworks, with its vast array of buildings and chimneys belching out smoke dominated the skyline, presented a scene at night not unlike a vision from hell. It was the largest gasworks in the world, employing thousands of people.

Ships loomed above the streets and long delays occurred at the dock bridges when they were opened to allow a ship to enter or leave the dock. The factories along the riverside from West Silvertown to North Woolwich made products which were used in every home and exported throughout the world. Each factory had its own distinctive hooter and smells which exuded into the streets and houses which were crammed into the space left between the docks and river. There were few green spaces where children could play but they could enjoy many happy hours going to and fro across the river on the Woolwich Ferry.

The strategic importance of Dockland made it a major target for the German bombers during the Second World War. Despite the often devastating raids which caused severe damage and loss of life, many people stayed on and worked in the factories making products for the war effort.

Thousands of people had left the area during the War, many of them never to return. The Docks and industry gradually recovered from the effects of the war. A growing volume of traffic came through the Docks and there were many jobs to be had in the factories.

The local authorities drew up plans for the redevelopment of the area which included the clearance of much of the old housing, the resiting of industry and the building of new housing estates and tower blocks.

Britain's trade patterns with the world were changing as many of the Commonwealth countries became less dependent on it and found new markets. The country was also faced with growing competition from Europe.

Mechanised methods of handling cargo rapidly were being widely adopted in the docks and inevitably the large workforce was savagely cut. The dockworkers fought strongly against the imposition of many of the new working practices which threatened the improvements in employment they had fought so hard for.

The docks were not the only industry decimated by advancing technology. Many of the long established factories moved away during the 1960s and 1970s, underwent 'rationalisation', reducing the number of people they employed, or closing down altogether.

The closure of the up river docks from the late 1960s and the Royal Docks in 1981 was an enormous blow, bringing immediate job losses to those who worked there and distress to the thousands of people who depended on them. A way of life had gone for ever. The people of Newham Dockland awaited a decision about their future.

Howard Bloch
November, 1994

One
Royal Docks

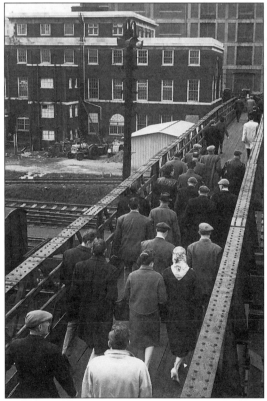

Thousands of men and women worked in the Royal Docks in jobs ranging from dockers and stevedores, office staff, customs officers, and ship scrubbers to seamen's missionaries. This photograph shows some of them crossing the bridge from Custom House station in to the Royal Victoria Dock in 1962.

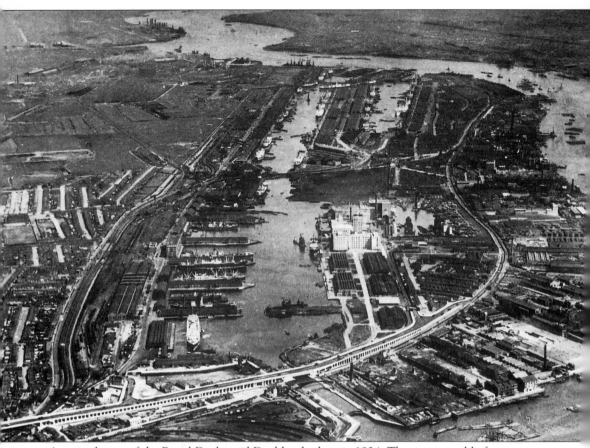

An aerial view of the Royal Docks and Dockland taken in 1934. The most notable features are the Royal Victoria Dock with its jetties on the north side against which ships are berthed, the tidal basin at the western end which gave its name to a district in Canning Town, the flour mills on the south side of the Dock, and the concrete viaduct of the Silvertown Way which was opened in 1934.

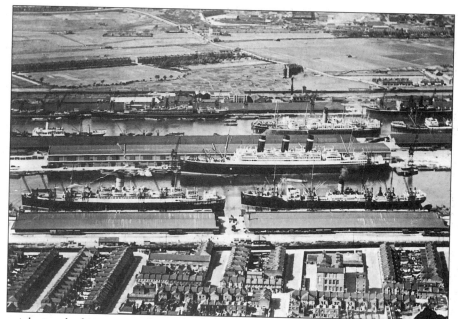

An aerial view looking across the King George V and Royal Albert Docks in 1924. To the north of the Royal Albert Dock is Savage Gardens, above them Beckton Gasworks, below is New Beckton (later Winsor) School in East Ham Manor Way and to the south of King George V Dock are the streets of North Woolwich, the most prominent building (to the right) is North Woolwich Secondary School.

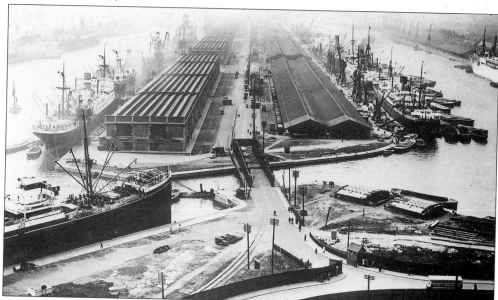

Looking west from Woolwich Manor Way in about 1935 to Gate 15 of the Royal Albert Dock, the swing bridge connecting the 'Centre Road' with the quay between the Royal Albert and King George V Docks. Warehouses stood on the north side of the King George V Dock and transit sheds on the south side of the Royal Albert Dock. These buildings were demolished to make way for the terminal and runway of the London City Airport, an airport served by short take off and landing aircraft which opened in October 1987.

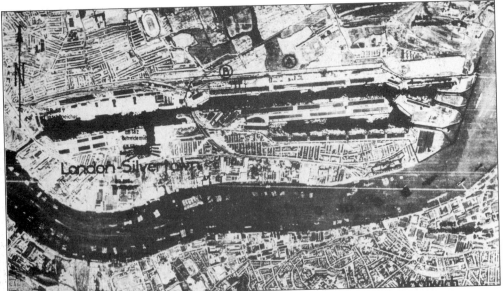

The German *Luftwaffe* collected information and produced photographs of their main targets. This aerial picture taken in June 1939 included a key to the buildings in the Royal Docks and the riverside factories which were considered to be of strategic importance.

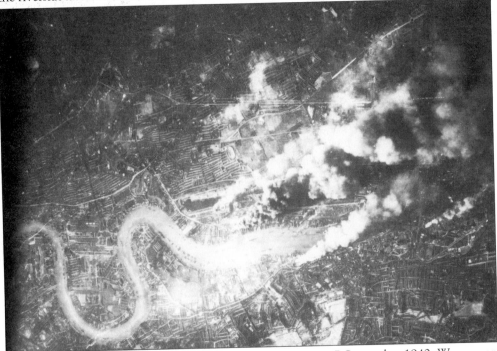

The Germans launched the Blitz on London at about 5pm on 7 September 1940. Wave upon wave of bombers flew up the River and made for the Docks, factories and Beckton Gas Works. Within minutes the riverside belt from North Woolwich to West Silvertown was ablaze. Acrid smoke and chemicals filled the air, making it difficult for the firemen and rescue services to pass. People took shelter wherever they could. The district became an inferno and later that evening hundreds of people were evacuated from the area.

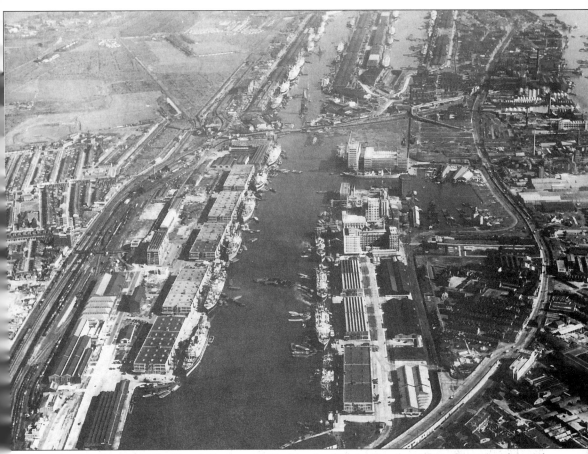

An aerial view of the Royal Docks and Dockland taken in October 1950. Compare this with the photograph on page 10. The Royal Docks were extensively modernised during the late 1930s and the jetties on the north side of the Royal Victoria Dock were replaced by warehouses and the new flour mills on the south side were built about this time. Evidence of Second World War bomb damage can be seen on several sites including Canning Town and Custom House and near the Silvertown By-Pass.

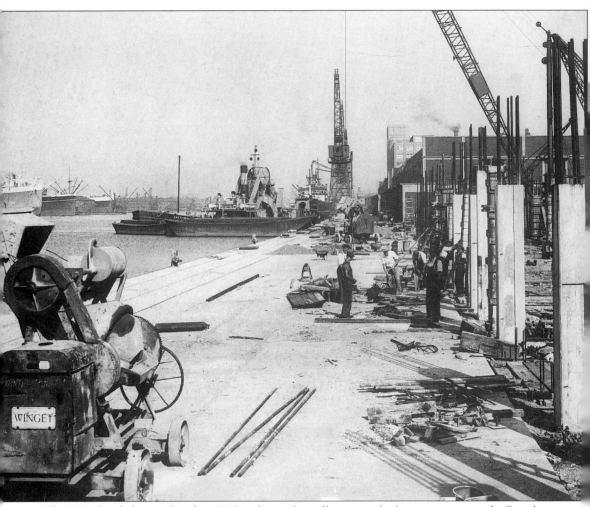

The PLA decided to go ahead in 1935 with a multi-million pound scheme to improve the Royal Docks so that they could deal with an increasing volume of trade. Work shown here on the south side included the construction of a three-storey reinforced concrete-framed transit and storage warehouse. The original jetties shown on the north side were demolished and replaced with a straight quay with modern warehouses. The importance of the Royal Docks in London's dock system was highlighted in the PLA's film the *City of Ships* which was made in 1939.

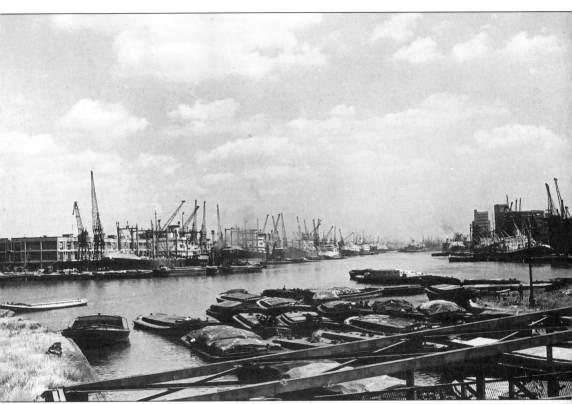

The Royal Victoria Dock in 1951. Many of the barges shown in the foreground would have come through the old entrance at the western end of the dock.

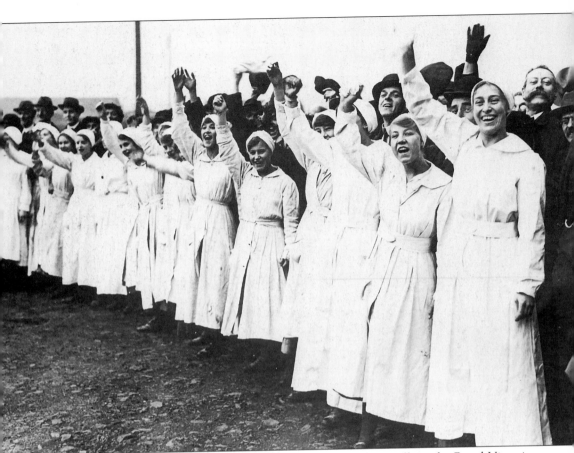

Women workers greeted King George V when he visited the flour mills in the Royal Victoria Dock on 15 November 1917. The King was offered a white overall as protection to his naval uniform but preferred to brave the dust.

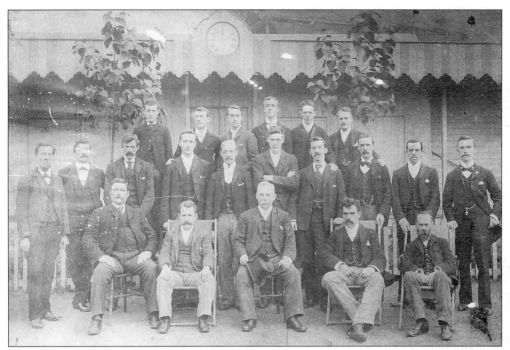

A group photograph of staff at Midland Railway Company's Victoria Docks goods depot taken in October 1894. The depot was located near the entrance lock at the western end of the Royal Victoria Dock.

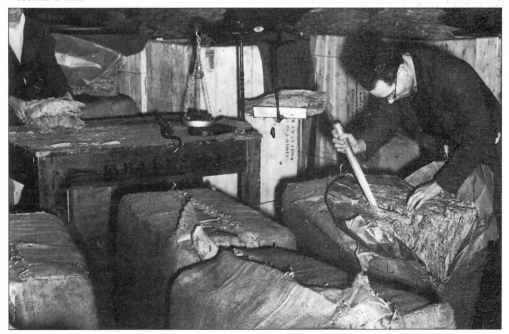

Bales of Rhodesian tobacco being sampled on the working floor of one of the warehouse in 1951. 'M' warehouse in the Royal Victoria Dock was London's largest tobacco store, where imported leaf was stored and matured until required by the importers and where trade operations were carried out.

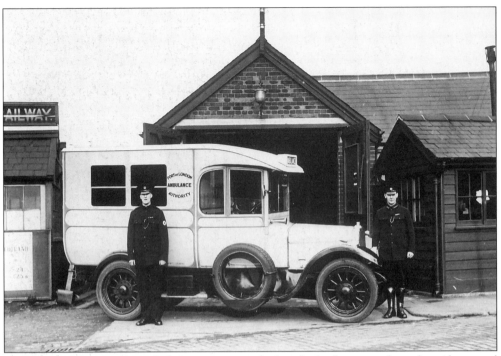

The PLA set up its own ambulance service to deal with the large number of accidents and injuries suffered by those who worked in the Docks. This photograph taken in the 1920s near Gate 8 Royal Victoria Dock, shows two of the specially trained police drivers standing next to one of the motorised fleet of ambulances.

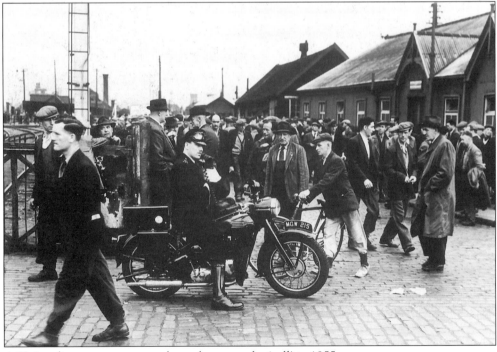

A PLA policeman on motorcycle on duty near the 'call' in 1955.

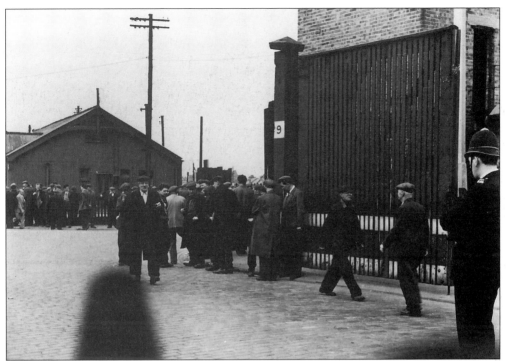

There were a number of firms who 'called off' men for work along the Connaught Road at 7.45am and 12.45pm including Scruttons, Maltby and the Royal Mail. Men are seen here near Gate 9 in 1955.

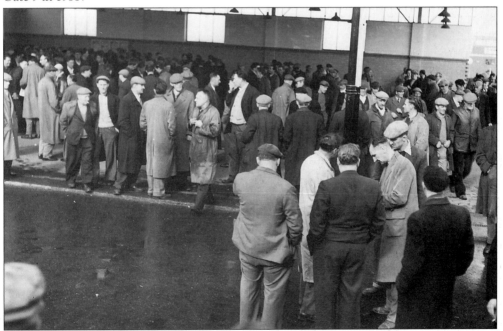

After failing to find work on the 'call' men stand under the shelter of the National Dock Labour Board office in 1962 and wait to show proof of attendance, which entitled them to a guaranteed wage.

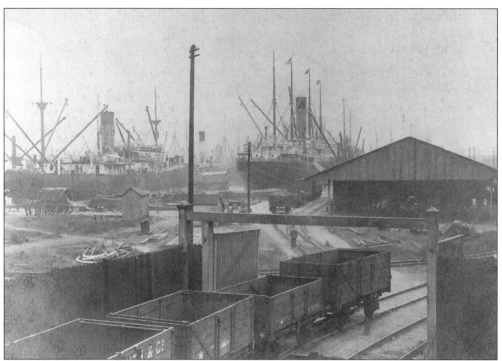

The Royal Albert Dock was opened in 1880 by the Duke of Connaught. It was the first large public undertaking in the country to be lit by electricity. This photograph taken in May 1909 shows the horse wagons and railways which served the dock.

A heavily loaded wagon crossing the Royal Albert Dock swing bridge in Woolwich Manor Way on 5 August 1909.

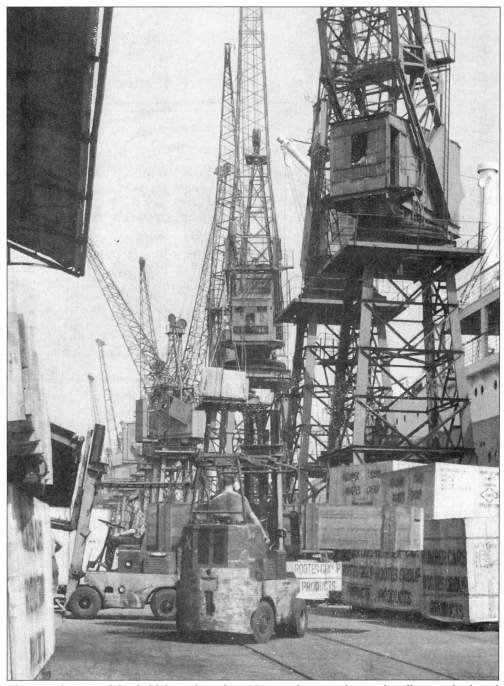

The introduction of the forklift truck in the 1950s revolutionised cargo handling methods and made possible the more efficient use of the space in transit sheds and warehouses.

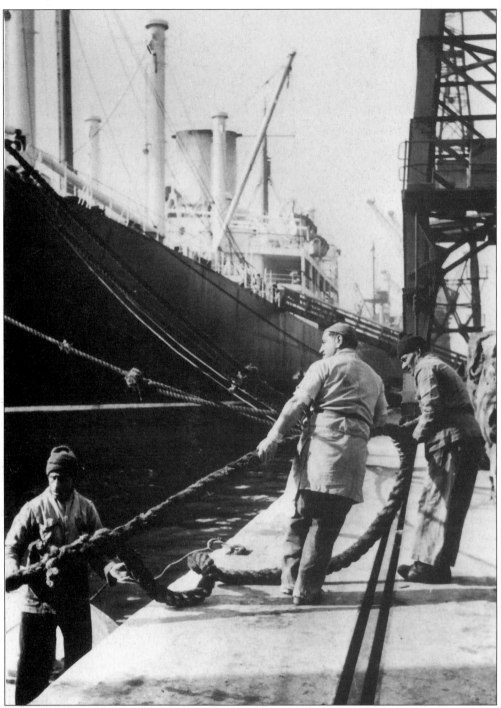

Lascars—Asian seamen—were employed in large numbers on the steam vessels, especially in the engine rooms of the major shipping lines which came to the Royal Docks, particulary the Peninsular and Oriental (P. & O.). They were a familiar sight in the streets around the Docks and were often to be seen walking together in single file carrying secondhand clothes, old bicycles and prams which they had bought from the street markets.

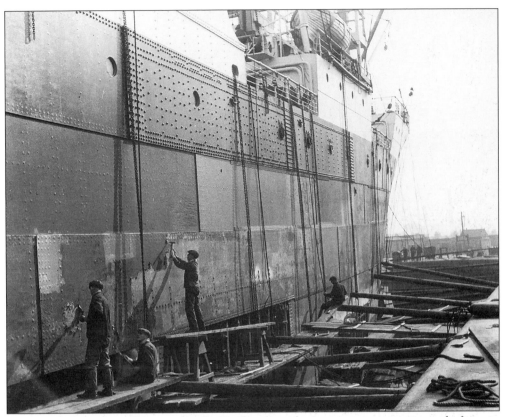

A number of the ships that came to the Docks after a long sea voyage were in need of repair. Men are seen here replacing plates and rivets on this ship in the Royal Albert Dry Dock in 1934.

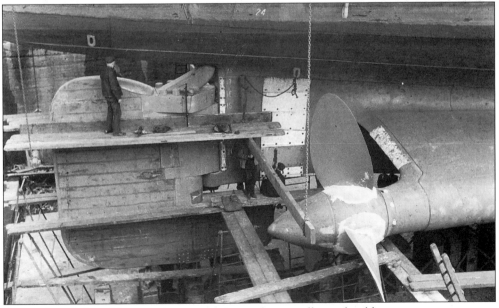

A view from below. Men carrying out repairs on the propellor and rudder.

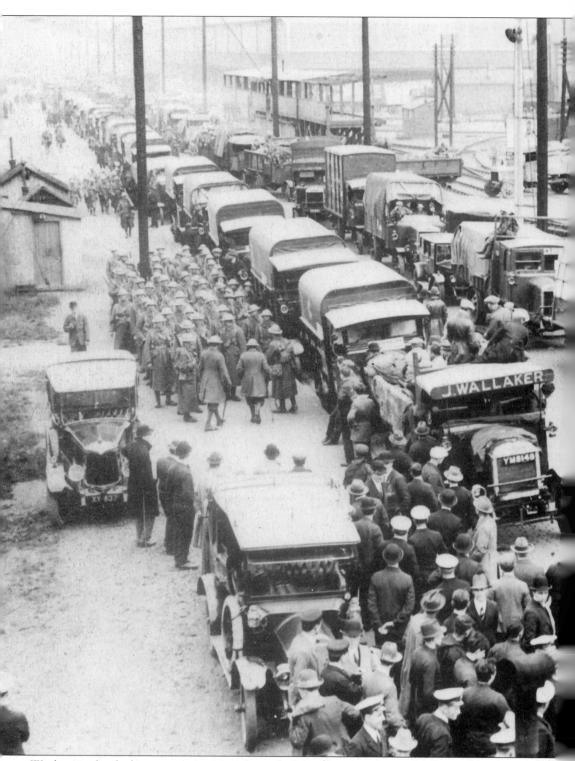

Workers in the docks came out in sympathy with the coal miners during the General Strike in May 1926 and the Government was obliged to bring in troops. They are seen here preparing to

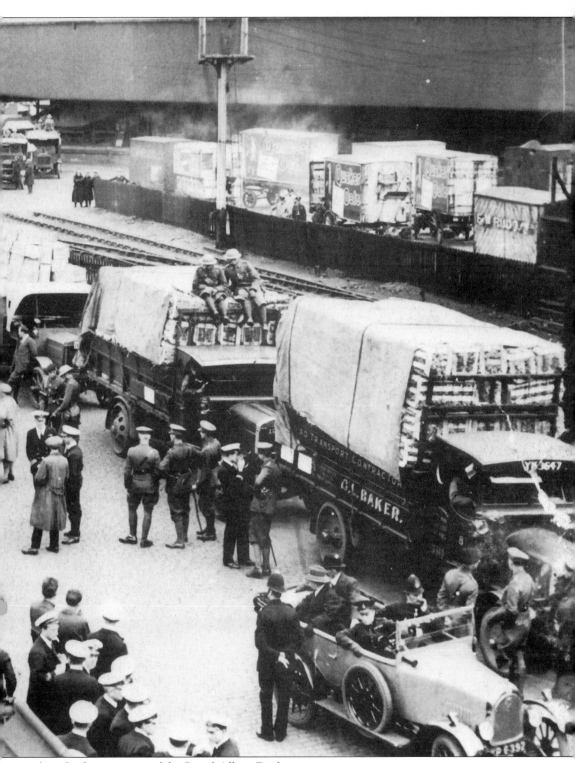

take a food convoy out of the Royal Albert Dock.

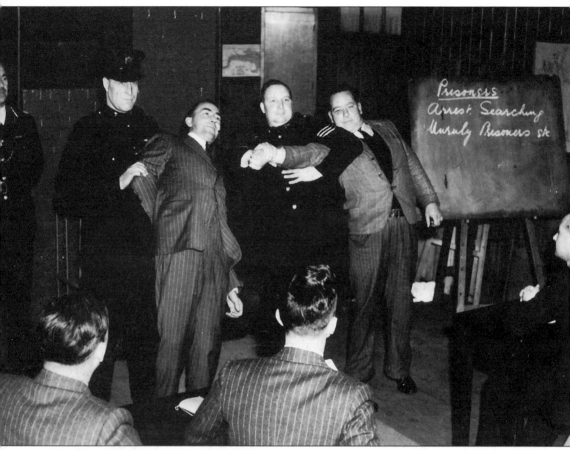

The PLA opened a school to train the large number of men who were recruited to their Dock Police Force after the Second World War. Set up in a wooden building in the Royal Albert Dock, their instruction included a knowledge of the relevant laws, patrol duties, the correct way to 'rub-down' suspected persons, the searching of ships for smuggled or stolen goods, methods of handling recalcitrant persons (shown here), and first-aid and life saving for dealing with accidents and immersion in the dock. This photograph was featured in an article published in 1946.

A view of one of the few streets in the Docks—Central Avenue in about 1930. The mock Tudor building on the far left is Central Station and next to it Miller, Rayner and Haysom seamen's outfitters.

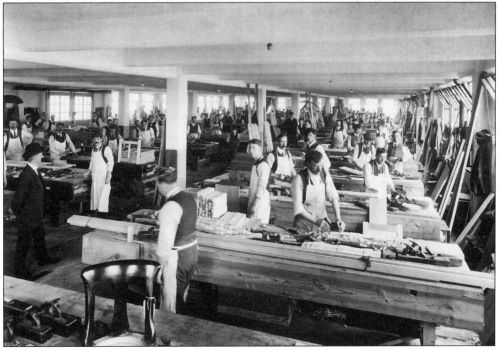

Joiners making furniture at a workshop in the Royal Albert Dock in about 1920.

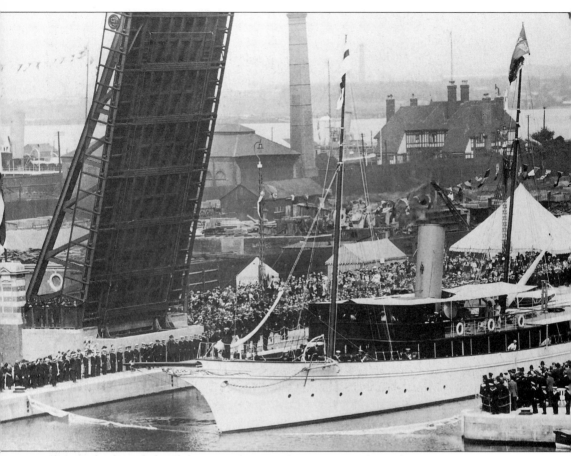

Thousands of people lined the riverside on 8 July 1921 to see the yacht *Rover* with King George V and the Royal Party on board as it passed by. The bascule bridge was raised and the yacht moved forward towards a band of white silk ribbon which was stretched across the entrance. The cheering and singing suddenly ceased and not a sound was heard as it caught the ribbon and stretched it until it snapped and the King George V Dock was opened. A great burst of cheering greeted the vessel as it entered the dock and berthed alongside a pontoon.

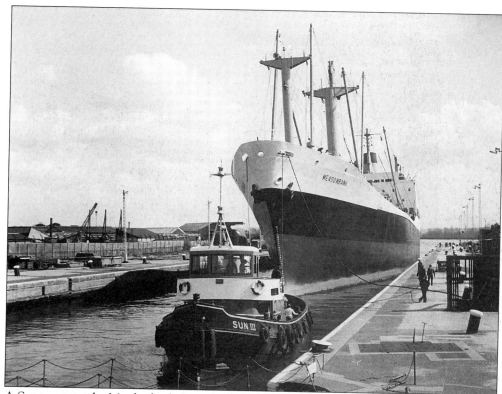

A Sun tug tows the *Meadowbank* through the King George V entrance lock in 1977.

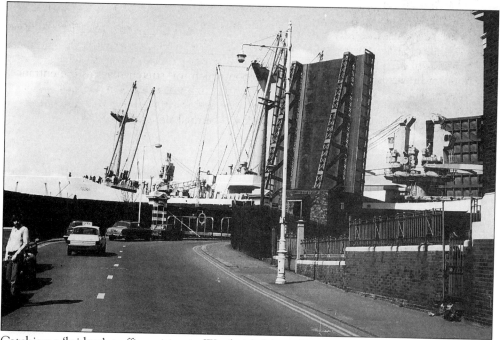

Catching a 'bridger', traffic waiting in Woolwich Manor Way in 1977 as the bascule bridge is raised so that a ship can enter the King George V Dock.

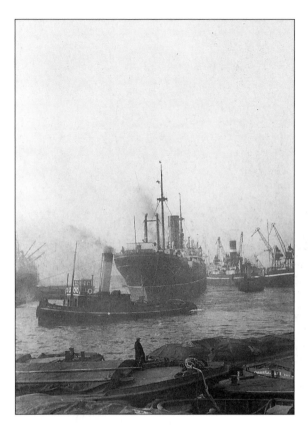

A lighterman stands on one of the barges that were tied together in the King George V Dock in 1934.

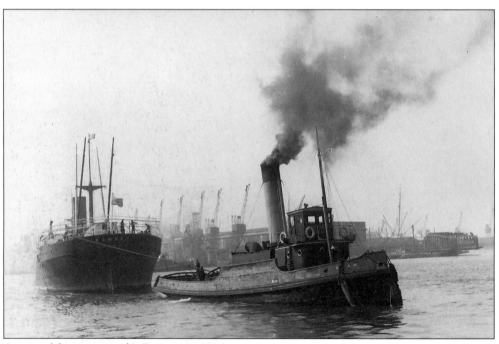

A powerful tug towing the *Romney* in 1934.

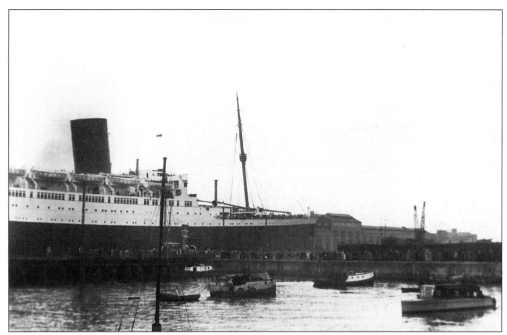

This snapshot was taken by one of the thousands of people who saw the Cunard-White Star liner *Mauretania* arriving at the King George V Dock on 6 August 1939 after her first Atlantic crossing. It towered above the Harland and Wolff works.

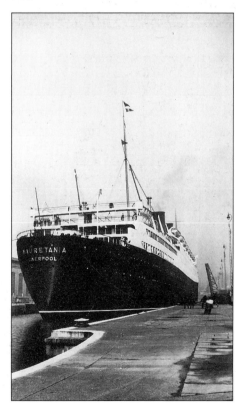

The *Mauretania* left on 11 August 1939 and went through the entrance lock with only inches clearance on each side. It was the largest vessel ever to come through the Royal Docks.

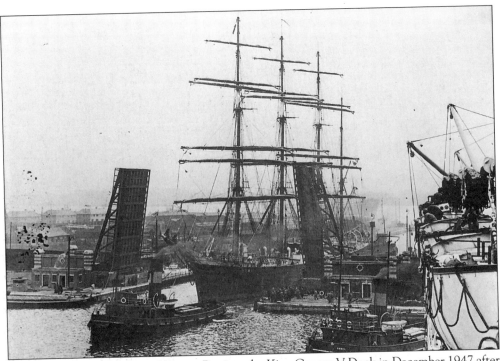

The arrival of the four-masted barque *Pamir* at the King George V Dock in December 1947 after her voyage from New Zealand which had created great public interest. She was used both as a sail training ship and to carry cargo.

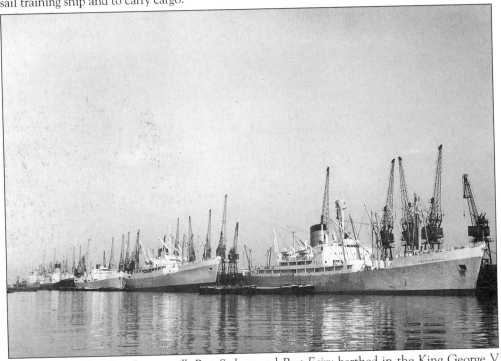

Port Line vessels—*Port Invercargill*, *Port Sydney* and *Port Fairy* berthed in the King George V Dock on 30 May 1960.

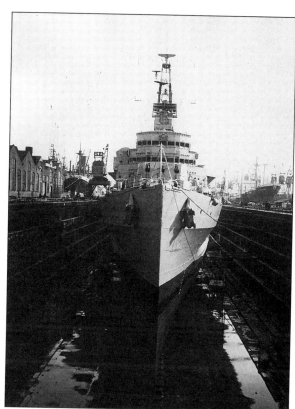

H.M.S. *Belfast* under restoration in the King George V Dry Dock on 10 October 1971. The vessel is now moored near Tower Bridge.

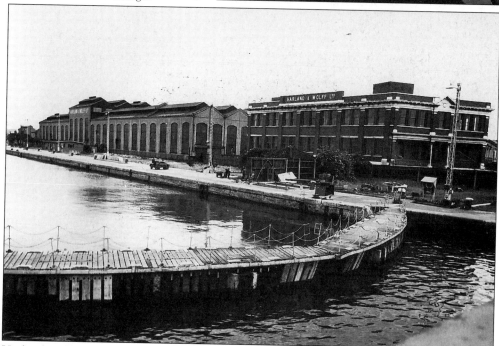

Harland and Woolff opened their shipbuilding, repair and works near the entrance to King George V Dock in 1924. It closed in 1972 and is seen here in 1973.

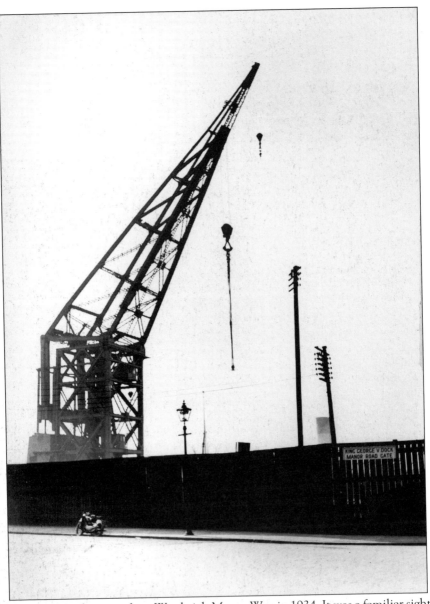

The *London Mammoth*, a view from Woolwich Manor Way in 1934. It was a familiar sight in the Royal Docks. The PLA's largest floating crane, it was capable of lifting loads of up to 150 tons, it was moved by tug to wherever it was required.

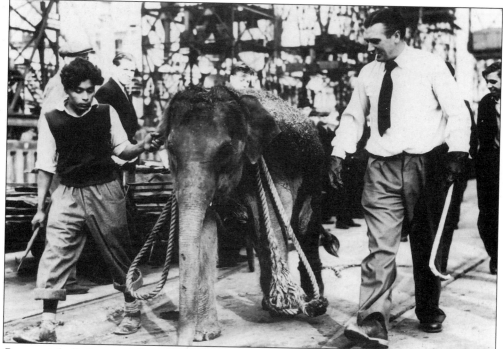

Cargoes of all shapes and sizes were handled in the Royal Docks. This two-year-old baby elephant arrived aboard the *SS Arabatus* at King George V Dock from Ceylon in October 1947. It was on its way to Tom Arnold's Christmas circus at Harringay.

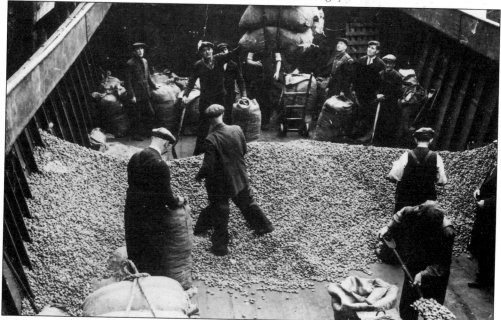

Rebagging West African ground nuts discharged to lighter at King George V Dock in October 1947, showing a needleman with his back to the camera, rebagging gang, weighers (in the foreground), and twine for sewing on the scales. One set is being hoisted ashore and another set made up ready for hoisting (left foreground).

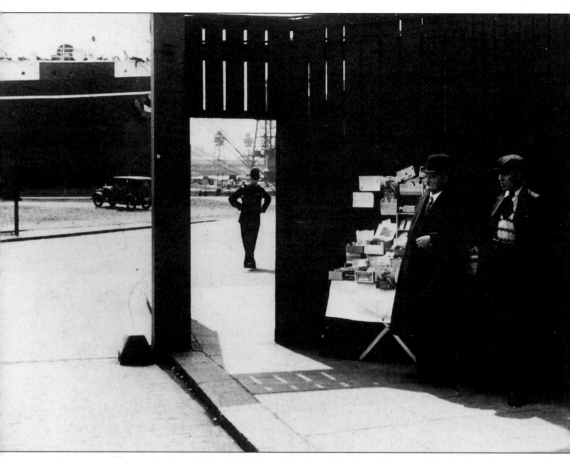

A sweet stall outside Gate 15 Royal Albert Dock in Woolwich Manor Way before the Second World War. Beyond can be seen a PLA policeman on duty and a ship berthed near the entrance to King George V Dock. Compare this with the aerial view at the bottom of page 11.

Two

Victoria Dock Road
and Custom House

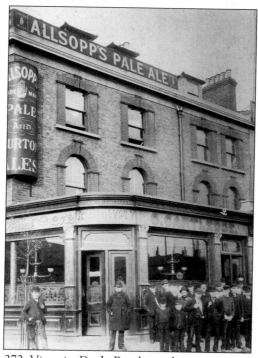

The Railway Tavern, 272 Victoria Dock Road, at the corner with Freemasons Road on 9 October 1891. There was a public house every few yards along the Victoria Dock Road. Filled with dock workers, factory workers and seamen they opened at six o'clock in the morning and served both as place for refreshment and a source of information about where work was to be had.

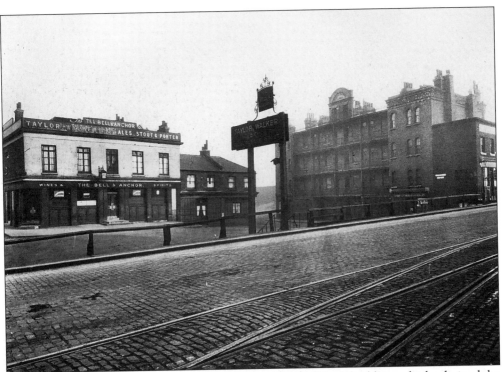

The Bell and Anchor public house and the tenement block Platt's buildings which adjoined the Dock Road and Tidal Basin swing bridge on 31 December 1931. They were soon to be demolished for the construction of the Silvertown Way.

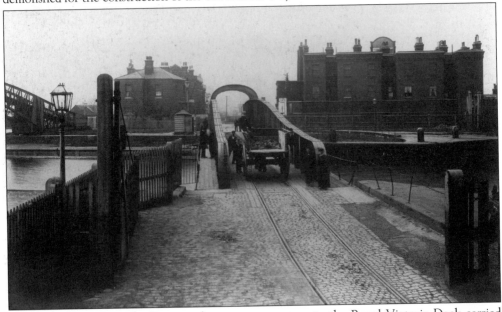

The Tidal Basin swing bridge over the western entrance to the Royal Victoria Dock carried both the road and the Silvertown Tramway railway line. With only a single line of traffic delays ocurred when the bridge was swung to allow ships to enter or leave the Dock. This photograph taken in 1904 shows Platt's Buildings on the right.

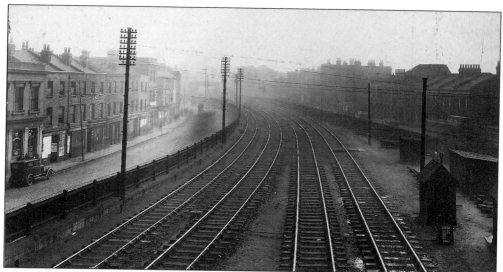

Victoria Dock Road on the left and Tidal Basin on the right and the railway to North Woolwich between on 9 March 1932. Many of the buildings have been boarded up and await clearance for the construction of the Silvertown Way.

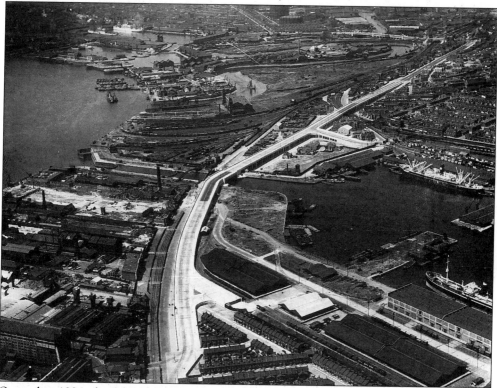

Opened in 1934, the Silvertown Way was designed to improve the flow of traffic to the Royal Docks by carrying it across the Victoria Dock Road, railways and Victoria Dock entrance on a massive concrete viaduct. The old swing bridge can be seen and the former Thames Ironworks offices and slipway with sailing barge in Bow Creek is just winding round to its last run to the Thames.

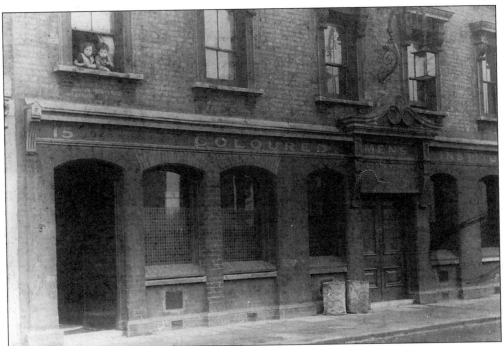

Pastor Kamal Chunchie, a Ceylonese-born Methodist minister, opened the Coloured Men's Institute in Tidal Basin Road in 1926 as a religious and social centre for black seamen who visited the Port and those who lived with their families in the area. The building was closed in 1930 when it was acquired for the construction of the Silvertown Way.

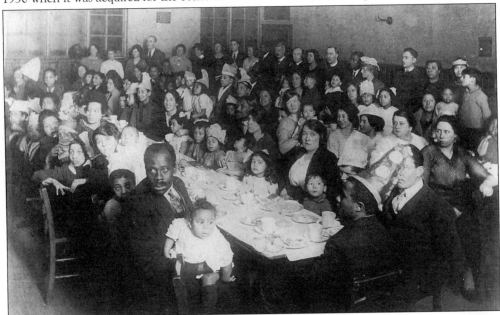

A Christmas party at the Coloured Men's Institute in 1926. Black seamen settled in the streets off Victoria Dock Road in the years before and during the First World War. A number married white women and lived in Crown Street which was known locally as 'Draughtboard Alley'. Canning Town and Custom House had the largest black population in London in the 1930s.

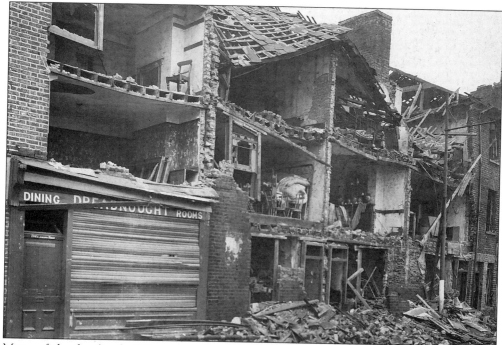

Many of the familiar buildings were destroyed during the Blitz. This photograph shows the Dreadnought Dining Rooms at 161 Victoria Dock Road and the adjacent houses between Rivett Street and Hack Road.

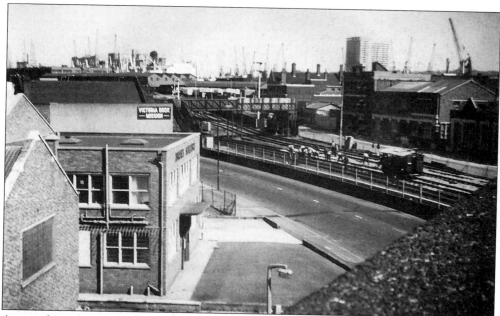

A view from the Silvertown Way taken in the 1960s, Victoria Dock Road is on the left and Tidal Basin Road on the right looking towards the Royal Victoria Dock. The Victoria Dock Mission of the Shaftesbury Society, originated as a Nonconformist church in 1869, was one of the many Christian organisations who sought to exert a spiritual influence on the local residents. Its site is now covered by Shaftesbury Society housing.

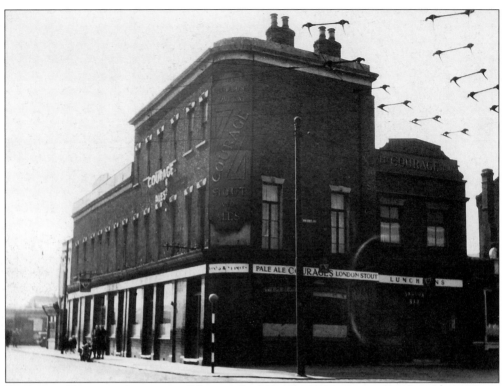

Freemasons Tavern at the corner of Victoria Dock Road and Freemasons Road in April 1951. It has been re-named The Barge in recent years.

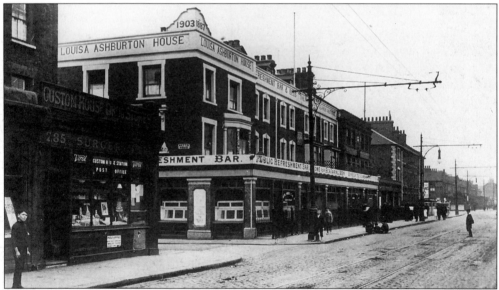

The British and Foreign Sailors' Society sought to provide seamen with an alternative to the lodging and public houses at Louisa Ashburton House in Victoria Dock Road. There were beds and a range of religious and recreational facilities including a hall, reading room and coffee palace. The main building was demolished in the 1930s and the Flying Angel hostel was built on the site.

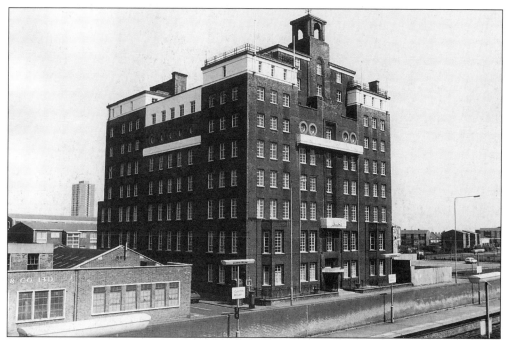

Dominating the dockside skyline, the Missions to Seamen opened its showpiece 'Flying Angel' hostel in Victoria Dock Road in 1936. The Asiatic Hostel opened in the adjacent Ashburton Hall in 1937 provided facilities for Indian seamen. Both buildings were badly damaged during the Blitz and the Asiatic Hostel was subsequently demolished. The Flying Angel seen here in 1984 is now owned by Beacon Hostels.

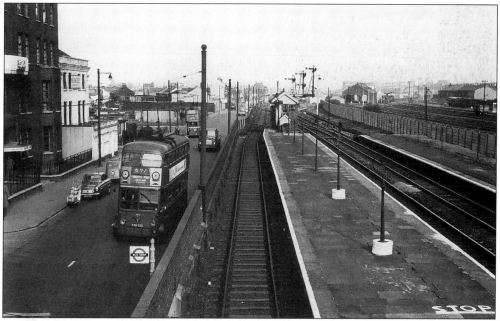

Victoria Dock Road in the 1950s looking east from Custom House Station. The Flying Angel is on the left and former Asiatic Hostel next to it. The PLA's extensive Exchange Railway Sidings which served the docks are on the other side of the fence on the right.

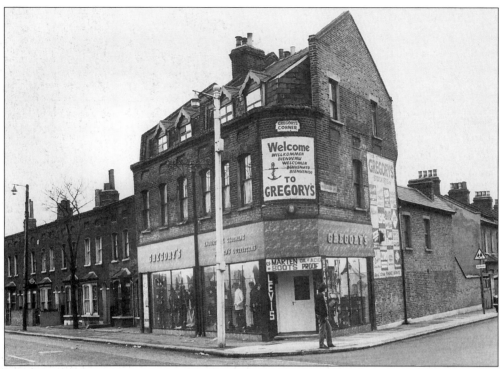

Gregory's, on the corner of Victoria Dock Road and Prince Regent Lane in December 1971. A place to go to pawn your belongings when times were hard and where seamen bought equipment and clothing to take on their voyage.

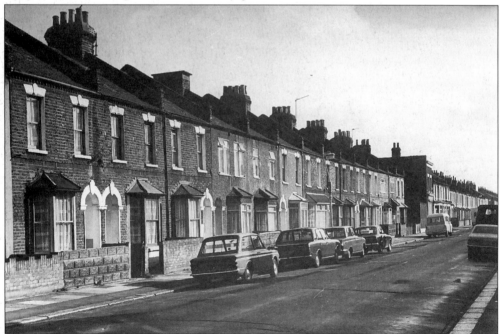

Leyes Road in 1977. Alnwick, Leyes, Prince of Wales and Royal Roads were demolished a few years later, prior to the redevelopment of Beckton. The land on which they stood is still vacant.

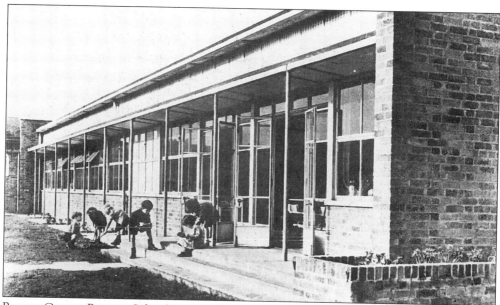

Regent County Primary School Infant Wing, 1950. The school replaced Prince Regent Lane School which had been bombed during the War. Built on one floor it was designed for 270 children. It now houses Elizabeth Fry School.

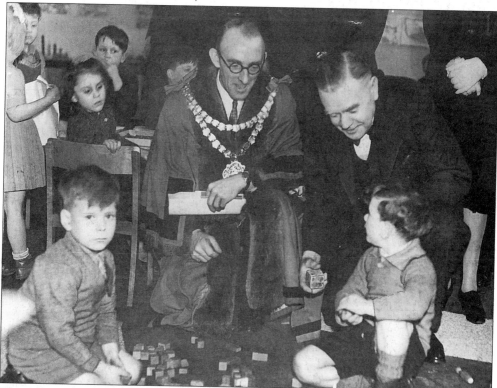

The opening of Regent School in 1949 by the Education Minister, George Tomlinson MP, and the Mayor of West Ham, Aldermen P. Hearn. It was first school to be opened by West Ham Council after the Second World War.

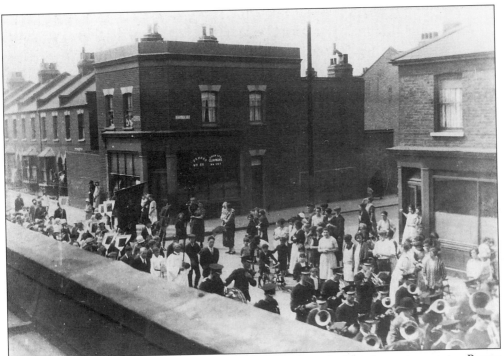

A procession from the Church of the Ascension at the festival of the Ascension passing Baxter Road.

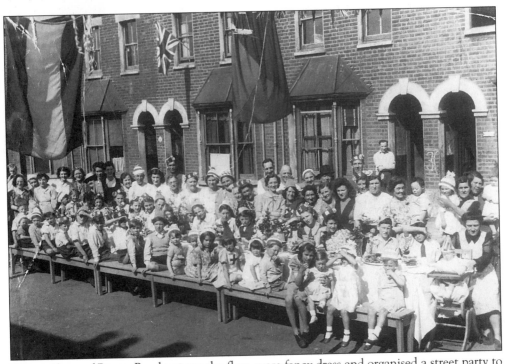

The residents of Baxter Road put out the flags, wore fancy dress and organised a street party to celebrate the Victory in 1945.

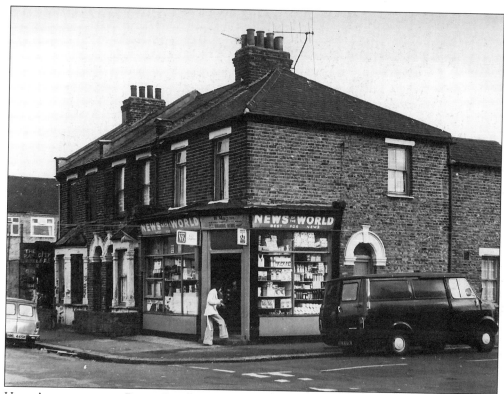

Hagan's newsagents in Baxter Road in 1977.

Colman Road on 10 February 1937. Many of the houses in this street were built in 1929–30 to accommodate those whose houses had been demolished to make way for the construction of the Silvertown Way. The fence of West Ham Stadium is on the left and 'The Moorings' housing development which had recently been built by the Church Army is at the top left.

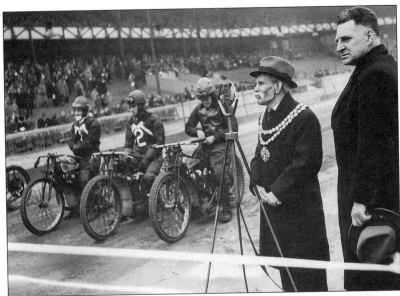

Crowds flocked in their thousands for a good evening out at West Ham Stadium. Opened in 1928, its main attractions were motor-cycle speedway and greyhound racing but it was also used for football, baseball and athletic meetings. The Mayor of West Ham, Aldermen Thomas Wooder, is seen here on 29 March 1940 opening the first speedway meeting after the outbreak of War.

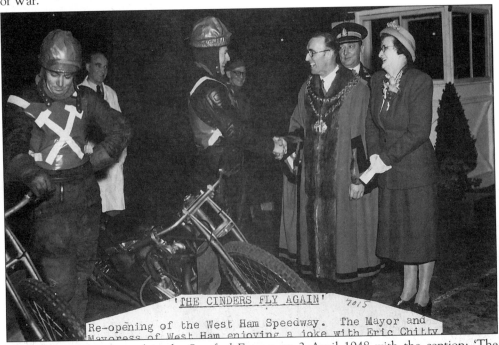

'THE CINDERS FLY AGAIN' 7015

Re-opening of the West Ham Speedway. The Mayor and
Mayoress of West Ham enjoying a joke with Eric Chitty

This photograph appeared in the *Stratford Express* on 2 April 1948 with the caption: 'The Cinders Fly Again—The Mayor and Mayoress of West Ham (Alderman and Mrs. P. Hearn) enjoying a joke with Eric Chitty, Hammers speedway captain, after the Mayor had re-opened the track on Good Friday. There was an attendance of 60,000— a record— and the Hammer's famous roar could be heard for miles around'.

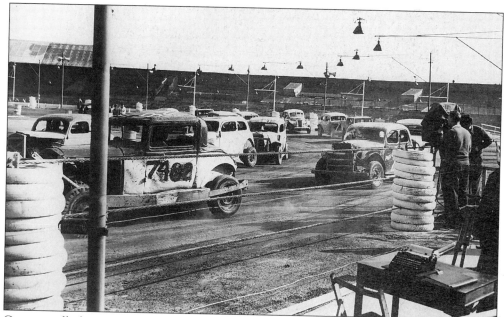

Cameras roll, shooting a scene for the film *Who done it?* in April 1956, which starred Benny Hill and Belinda Lee.

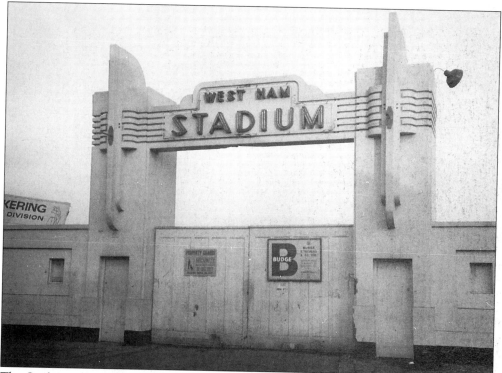

The Stadium closed in 1972. The entrance gates in Nottingham Avenue were retained but were subsequently demolished. The streets built on the site of the Stadium were named after the leading West Ham speedway riders—Arthur Atkinson, Tommy Croombs, Johnnie Hoskins, Bluey Wilkinson and Jack Young.

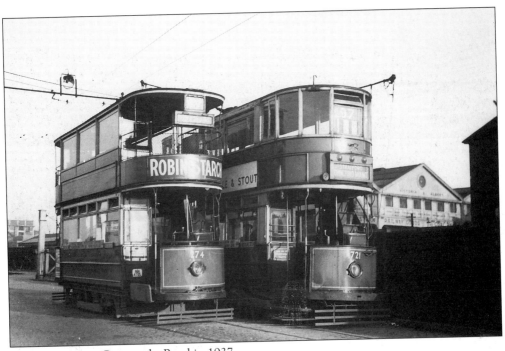

Trams waiting in Connaught Road in 1937.

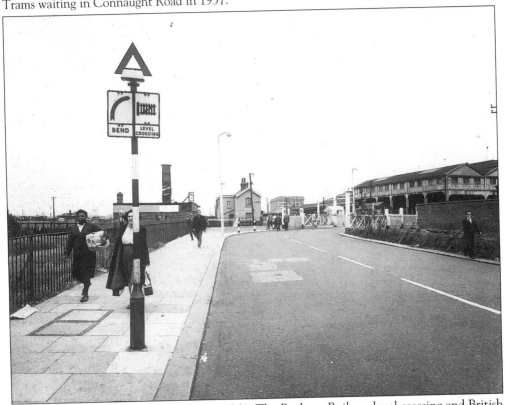

Connaught Road looking east in August 1961. The Beckton Railway level crossing and British Railway's Western Region Goods Depot are on the right.

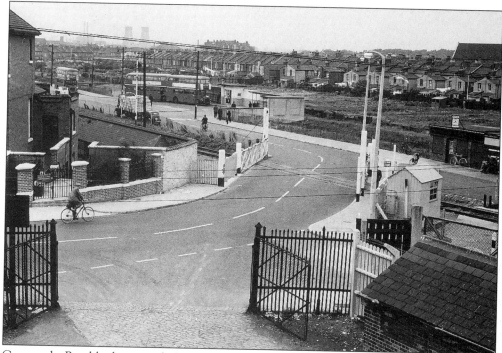

Connaught Road looking north from the corner near the Mercantile Marine Office in August 1961. Morgan's stall is on the right and the allotments behind at the back of the houses in Leyes Road.

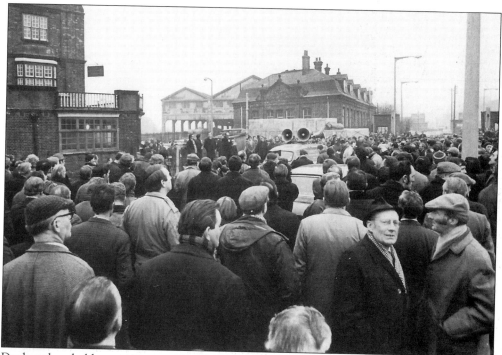

Dockworkers held a meeting near the Connaught Tavern in January 1971 to protest against the Government's Industrial Relations Bill.

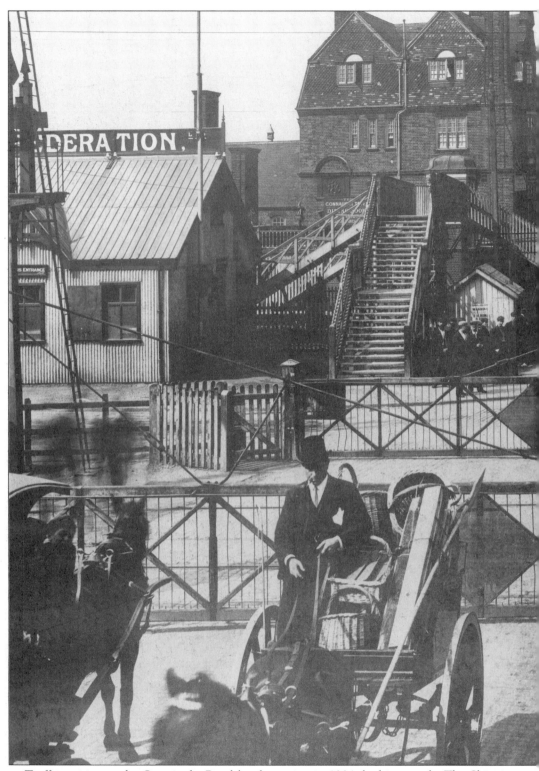

Traffic waiting at the Connaught Road level crossing in 1904, looking north. The Shipping

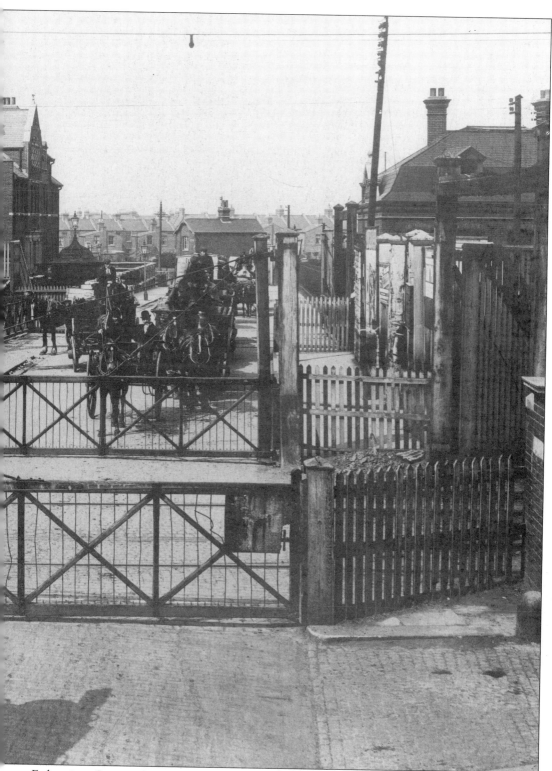

Federation, Connaught Tavern and urinal and the Board of Trade building are on the left.

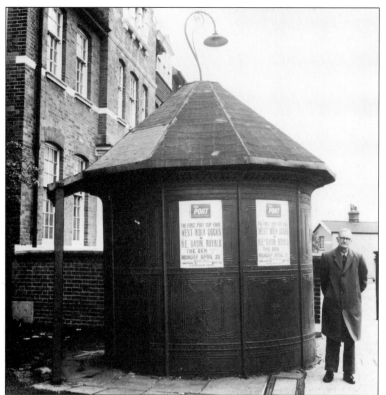

The Victorian cast iron urinal seen in front of the Connaught Tavern in 1971. Known as the 'iron lung' it was one of the few such facilities provided for dockworkers. It often smelt very strongly. A Grade II listed building, it has stood derelict for a number of years beside the closed public house.

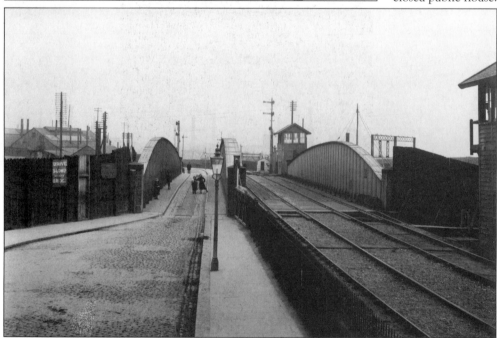

The Connaught swing bridge carried the road and railway across the channel between the Royal Albert and Victoria Docks and when operated allowed ships to pass through. This photograph was taken in 1904.

Three

Beckton

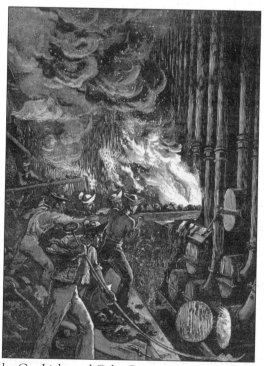

Land was acquired by the Gas Light and Coke Company on to build a new gas works to supply London's growing needs. The Company's Governor, Simon Adams Beck, drove the first pile on the river wall for the new works in 1868, it was named in his honour 'Beckton' and gas production began two years later. This engraving from the *Illustrated London News* of 1878 shows men feeding the retort ovens with coal and the conditions in which they worked.

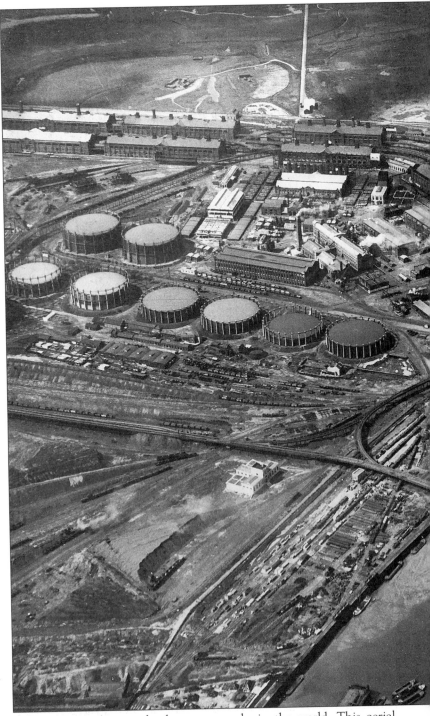

Beckton Gasworks was the largest gasworks in the world. This aerial photograph was taken in the mid-war years. Coal was brought in colliers from the North-East of England and unloaded at the piers. From there it

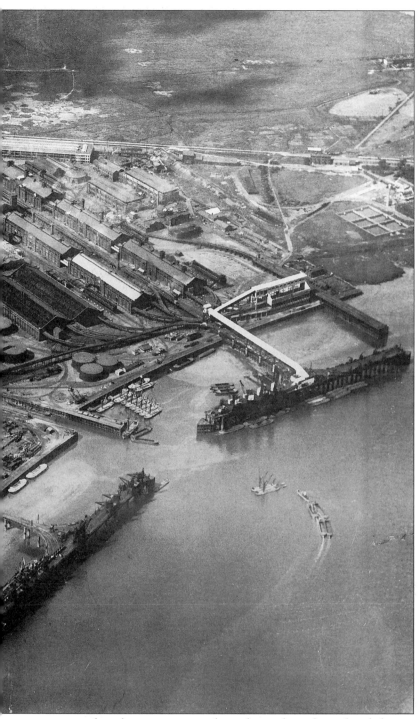

was conveyed to the retort ovens where the coal was heated and the gas driven off. This was purified and stored until it was distributed to thousand of homes and factories in London.

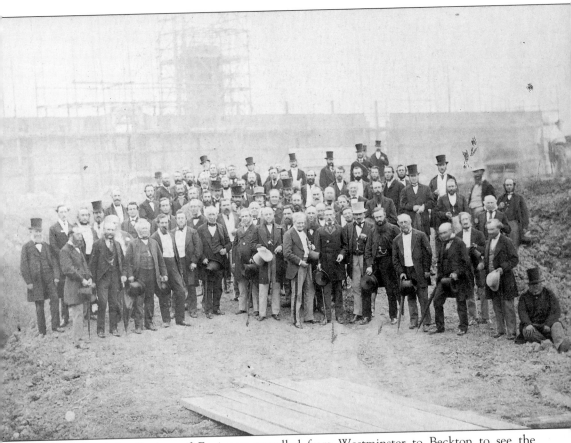

Members of the Society of Engineers travelled from Westminster to Beckton to see the gasworks under construction in September 1869.

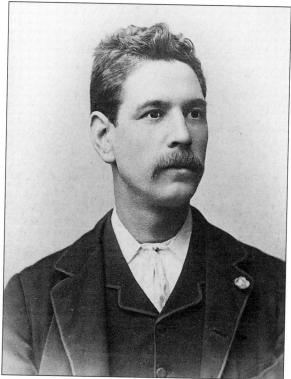

Will Thorne led the workers at Beckton Gasworks in their fight against the increased use of machinery and the introduction of an eighteen-hour shift. He founded the Gasworkers and General Labourers Union at a meeting in Canning Town and within two weeks had recruited over 3,000 members. The Union won their fight for the eight-hour day. Thorne became the Secretary and was helped and encouraged in this post by Eleanor Marx. Two years later he became a West Ham councillor and in 1906 MP for West Ham South.

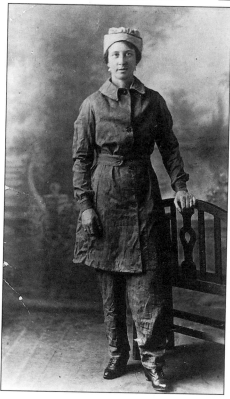

As the First World War went on more men were called up to serve in the Forces and women took over jobs which had never been open to them before. Mrs. Lillicrap, seen here in a studio portrait taken in 1917, was employed in the works department of Beckton Gas Works.

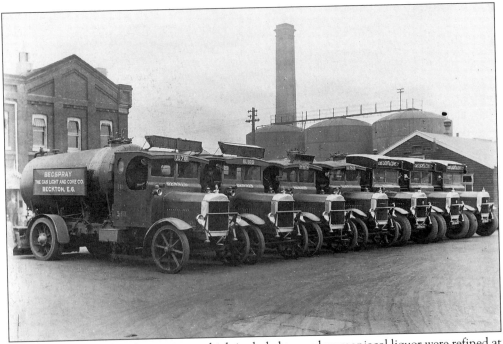

Residues from the gasmaking process which included tar and ammoniacal liquor were refined at the Company's By-Products Works and made into a range of products including tar and insecticides, and the ingredients used in the explosives and plastics industries.

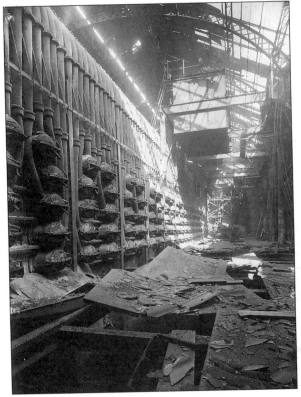

Interior of a retort house at Beckton Gasworks on 10 September 1940. The Germans had chosen Beckton Gasworks as one of its major targets. Bombs and incendiaries were dropped during the Blitz causing extensive damage to the gas holders, retort houses and plant and gas mains. The staff worked in often dangerous conditions to restore the supply as speedily as possible to both domestic and industrial users.

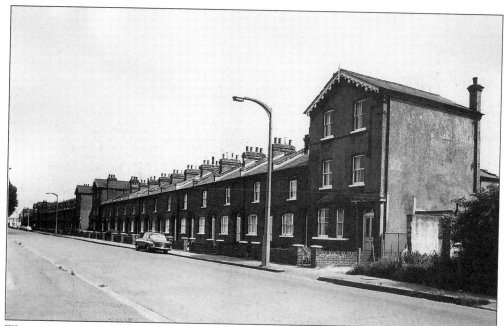

Winsor Terrace seen here in 1973 was built shortly after the opening of Beckton Gasworks to house their workers. Some of the houses on both sides of the street were destroyed during the Second World War. New houses now being being built on the Winsor Park Estate have been designed in complementary style.

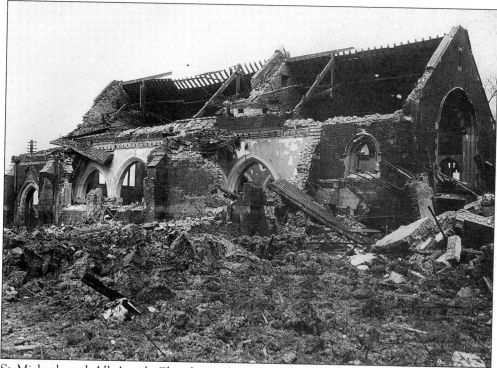

St Michaels and All Angels Church stood at the corner of Winsor Terrace and East Ham Manor Way. It was badly damaged by bombing on 19 April 1941 and subsequently demolished.

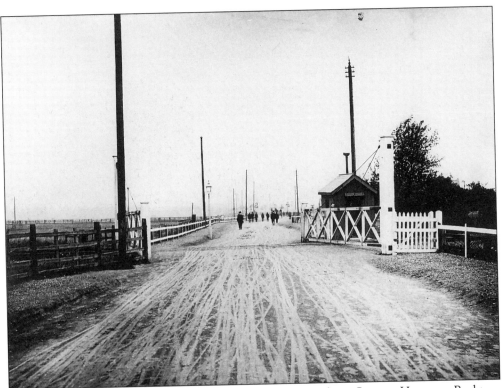

The Gas Light and Coke Company opened a railway line from Custom House to Beckton, which it leased to the Great Eastern Railway. This is the level crossing over East Ham Manor Way looking north to East Ham in 1903. There were open fields on both sides.

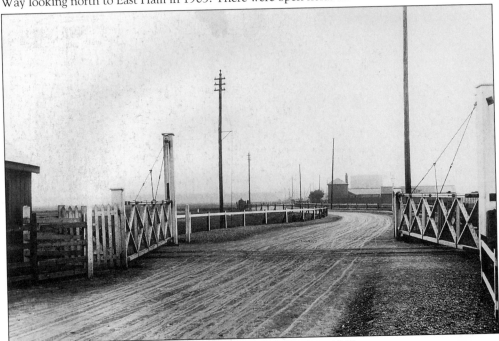

Beckton Railway level crossing looking south to Woolwich in 1903.

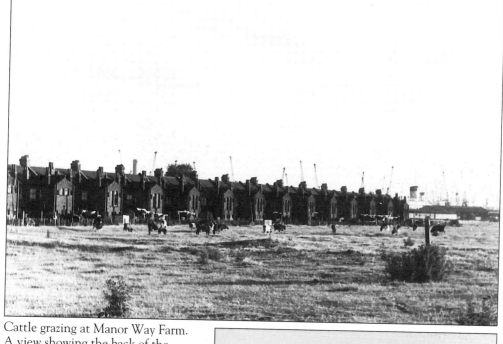

Cattle grazing at Manor Way Farm.
A view showing the back of the
houses in Savage Gardens in about
1960.

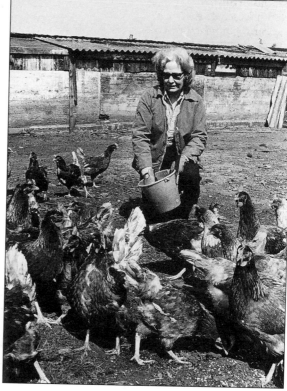

Mrs Grace Bedall feeding chickens at
Manor Way Farm. In an article in
the *Newham Recorder* in 1977 she
claimed that her family had run the
farm for 200 years and would fight
against its acquisition by Newham
Council for the development of
Beckton.

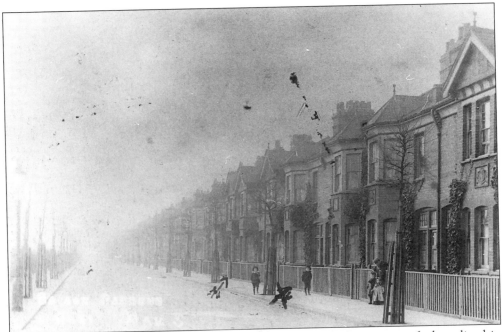

East Ham Council sought to provide improved housing for workers, many of whom lived in overcrowded conditions and whose work was casual and wages were low. They built a number of tenements in Savage Gardens which were opened in 1903.

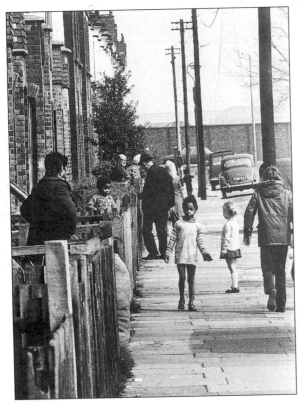

Isolated from the rest of the Borough the residents of Savage Gardens acquired a social stigma as a result of the large number of problem families who were allocated housing there by the Council. This photograph shows the street in the 1970s looking east.

Players at East Ham United Football Club's ground in East Ham Manor Way in the 1970s. The derelict buildings of Beckton Gas Works can be seen in the background.

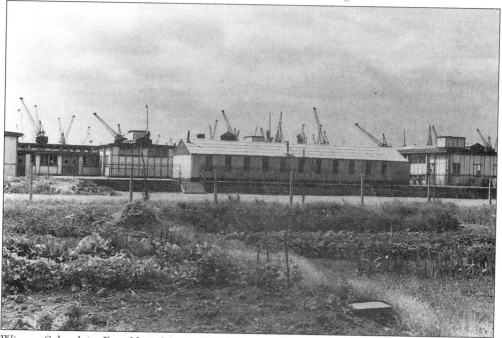

Winsor School in East Ham Manor Way in 1952. The original building was destroyed by bombing in 1940 and reopened in huts in 1944. The temporary prefabricated school shown here was built in 1947 and enlarged in 1954. A new school built in the 1980s for Beckton's new growing population now stands on the site.

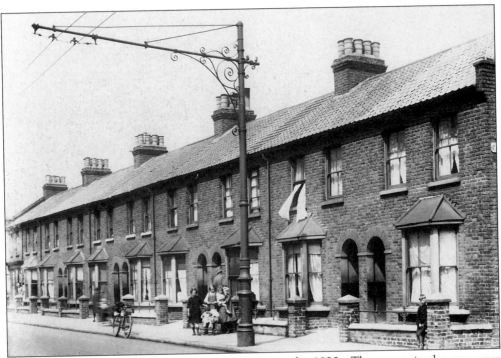

Cyprus Place at the corner with Shepstone Street in the 1920s. The streets in the area were built in the 1880s and their names derived from people and places in the news during the previous decade including the explorers Livingstone and Stanley, and the Prime Minister Lord Beaconsfield. The British took over the administration of Cyprus from Turkey in 1878.

Beaconsfield Street in 1971. Many of the original houses were destroyed by bombing and replaced by prefabs. New Beckton Baptist Church is on the right.

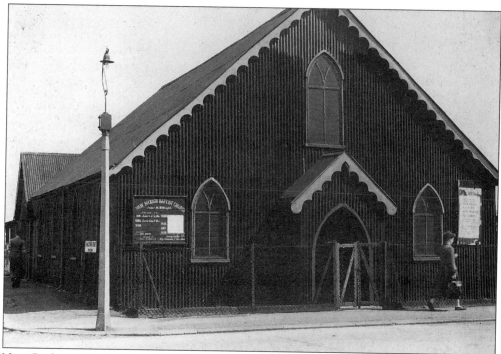

New Beckton Baptist Church was built in 1888 in Beaconsfield Street at the corner with Livingstone Street. Seen here in 1952 it was damaged by fire in 1978 and subsquently demolished.

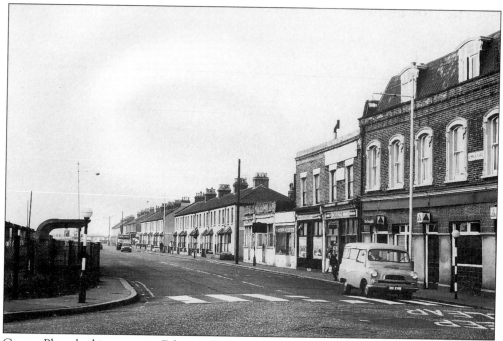

Cyprus Place looking west in February 1971. The Ferndale public house is at the corner, the shops nearby included numbers 40 Oakes newsagents, 35 Rose's cafe, 17 Arthur Harrington grocer, 7 Sisters cafe.

Ferndale public house and houses in Ferndale Street in February 1971. The Ferndale was a familiar destination to those who rode on the trams as it marked the terminus of the route as they could not go any further south because of the swing and bascule bridges over the Docks.

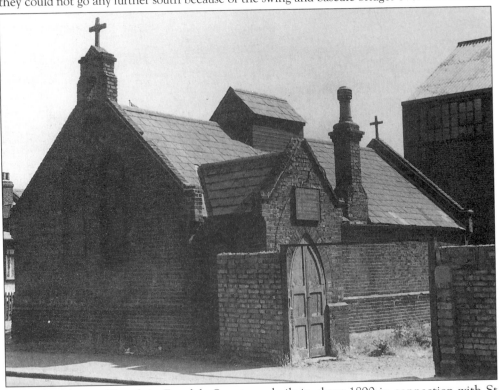

St Mark's Mission Church in Ferndale Street was built in about 1890 in connection with St Michaels and All Angels Church, Beckton. An iron hall was added at the expense of the Gas Light and Coke Company in 1911. The building was closed in 1952.

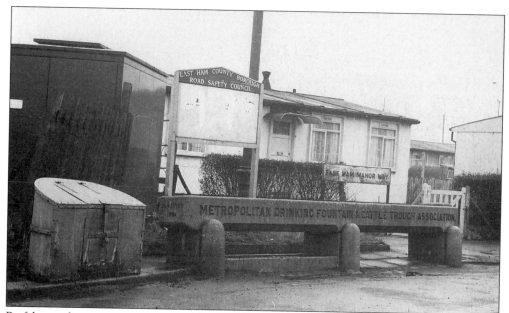

Prefabs at the corner of East Ham Manor Way on 21 February 1965. Large numbers were erected to house people made homeless after the war around Cyprus. These included Learoyd and Ryder Gardens, Stannard Crescent and to the north Sherbrooke Gardens. Some of them survived until the 1980s.

Before development could take place on the Beckton Marshes it was necessary to replace the old surface drainage channels with the Beckton surface water pumping station. The building was completed in 1977.

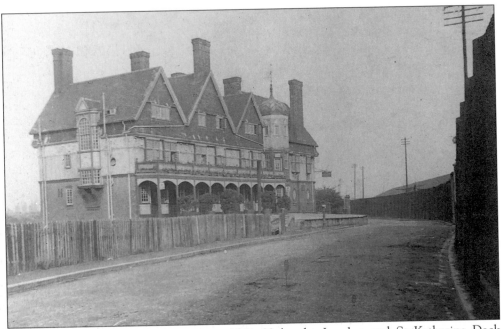

The Gallions Hotel was built in about 1881–83 by the London and St Katharine Dock Company to serve passengers boarding liners from the adjacent jetty. It had a fine plaster frieze on its exterior and magnificent interior fittings.

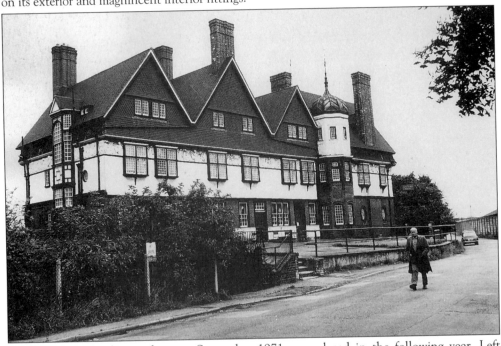

The Gallions Hotel, seen here in September 1971, was closed in the following year. Left derelict, it was subjected to a considerable amount of vandalism and was in very poor condition. Planning permission was sought in 1989 to move it to an alternative site but the proposal was subsequently abandoned. The building is currently under restoration and a new use is being sought.

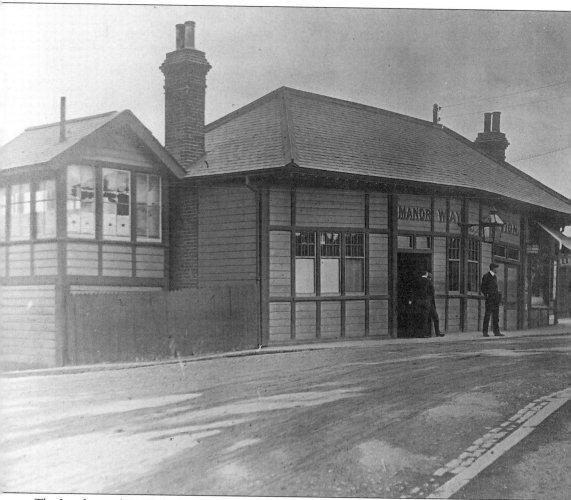

The London and St. Katharine Dock Company built their own railway along the north side of its new dock, the Royal Albert Dock, in 1880. With stations at Connaught Road, Central, Manor Way and Gallions it served both those who worked in the docks and ship passengers. This is Manor Way station in September 1908.

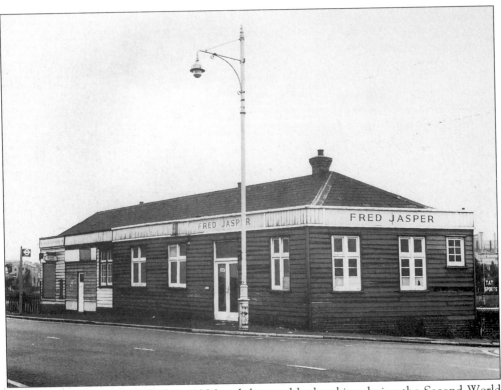

Manor Way station was rebuilt in 1926 and damaged by bombing during the Second World War. The buildings seen here in 1971 were used as shops and offices after the closure of the line in 1940.

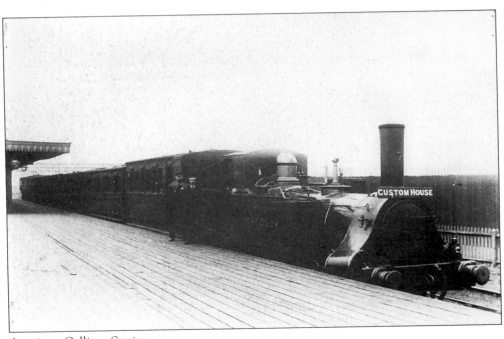

A train at Gallions Station.

Four
Silvertown

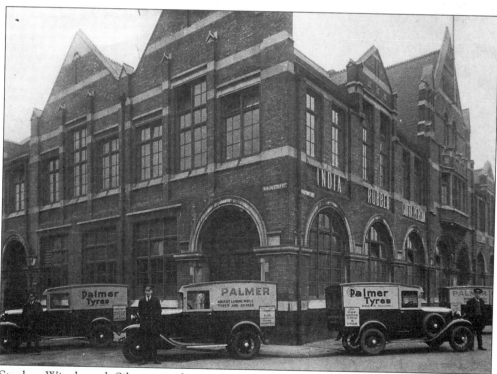

Stephen Winckworth Silver moved to a site on the riverfront in 1852 and established a factory to manufacture waterproof clothing and gave his name to the new district 'Silvertown'. This photograph was taken outside their works at the corner of Winchester Street and Factory Road.

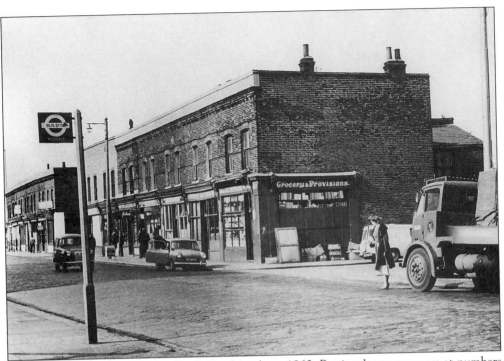

Looking west along North Woolwich Road in about 1960. Pattison's greengrocers at numbers 241-243 is at the corner with Eastwood Road.

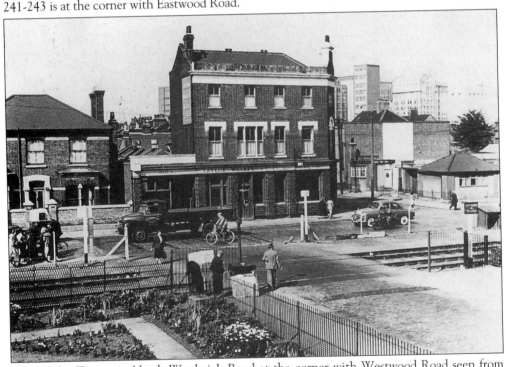

The Jubilee Tavern in North Woolwich Road at the corner with Westwood Road seen from Knight's soap works in about 1960. Many people travelled to work by bicycle or motorcycle at this time.

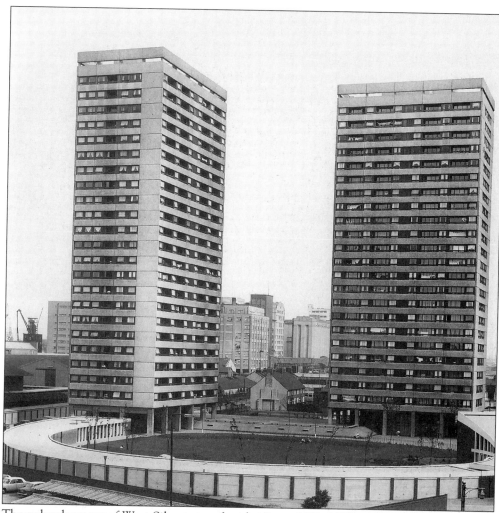

The redevelopment of West Silvertown after the Second World War included the demolition of the surviving terraced houses and the building of Barnwood Court. This included two 22-storey tower blocks—Cranbrook and Dunlop Points, shops, community centre and a public houses. Seen here in 1967 it won the Civic Trust design award in the following year. Rundown and neglected in recent years, plans have recently been made to demolish the estate and build the West Silvertown 'Urban Village' there.

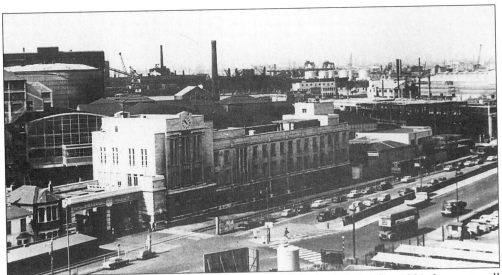

Abram Lyle & Sons established their sugar refinery at Plaistow Wharf in 1881. Its most well known product Golden Syrup has been manufactured there since 1885. The office block in North Woolwich Road was designed in the 1930s but construction was delayed until after the Second World War and it was opened in 1950. This photograph was taken in 1958.

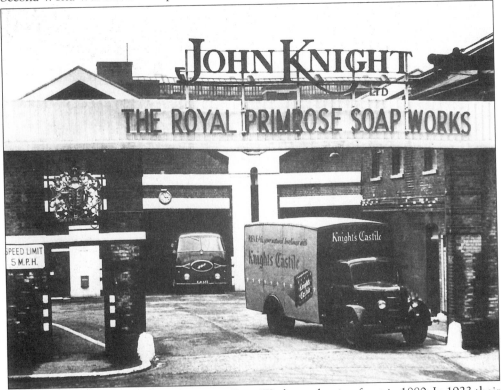

John Knight's opened their Royal Primrose Soap Works on the riverfront in 1880. In 1923 their factories on the site made household, soft and toilet soaps and included oil mills, seed and cake warehouses and factories for melting and glue making. Its Royal Primrose and Knight's Castile brands of soap were world famous.

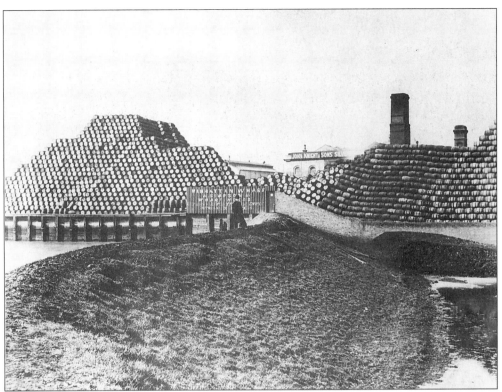

The petroleum merchants William Simpson & Co. stored their barrels on the riverfront at Manhattan Wharf. John Knight's soap works can be seen in the background.

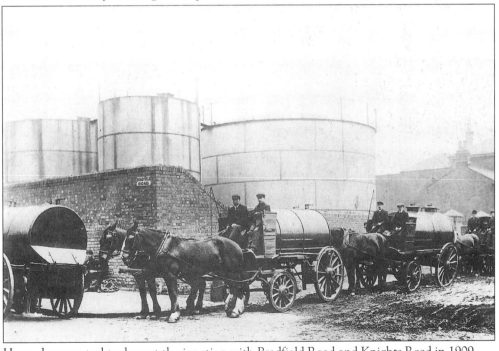

Horse-drawn petrol tankers at the junction with Bradfield Road and Knights Road in 1909.

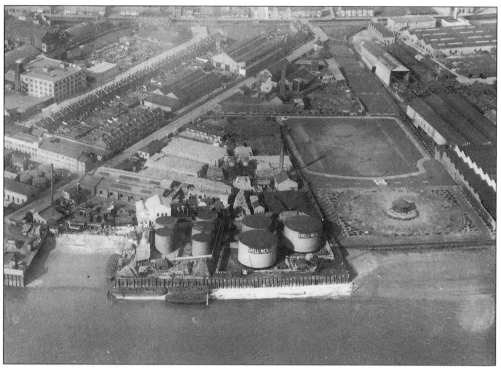

One of the few green spaces in Silvertown, Lyle Park was opened in 1924. Its location amidst the factories and oil storage wharves can be clearly seen in this view taken in the mid-War years. It was financed by the Lyle family who ran the nearby sugar refinery at Plaistow Wharf.

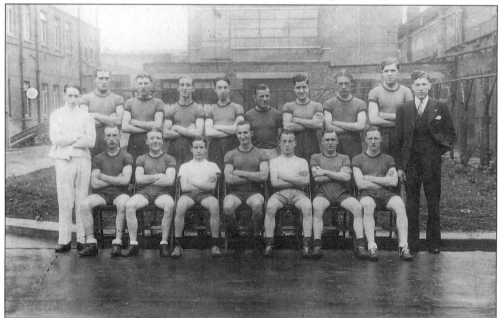

Many of the local factories encouraged their employees to use their sports and recreational facilities. This photograph shows a boxing team at the plywood and packaging case manufacturers Venesta's in about 1938.

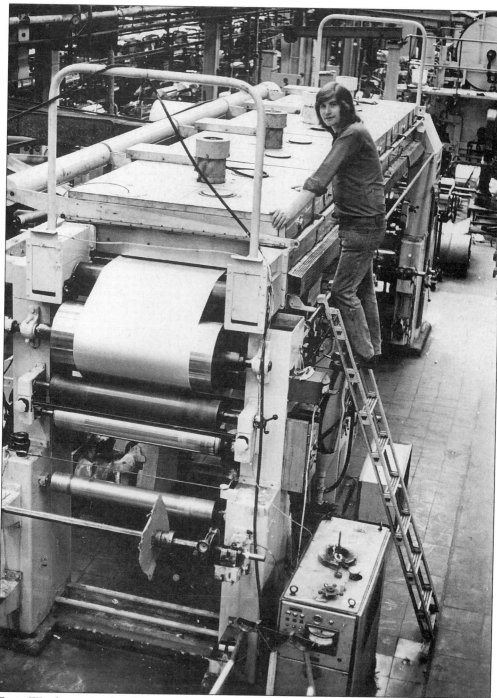

Ernie Wright at a coating/laminating machine in Alcan's Coating Department in the 1970s.

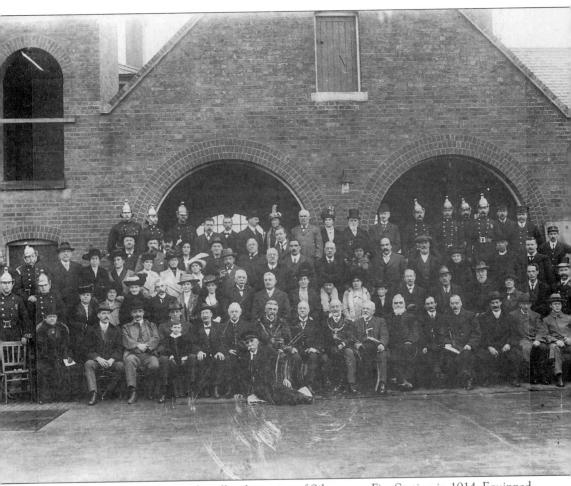

A group photograph taken at the official opening of Silvertown Fire Station in 1914. Equipped with the most up-to-date motor driven engines the station served an area in which there were large number of factories and wharves with high fire risk. The fire station was destroyed less than three years later in the Silvertown Explosion. Fireman Sell (top row, first from left) and Sub-Officer Vickers (top row third from left) were killed. Firemen Betts (top row, third on the right) and Chapple (top row, sixth from the right), Station Officer S.S. Betts (third row, second from left) and Yabsley second row, second from left) were injured.

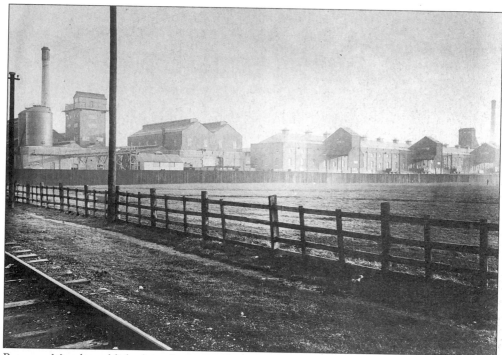

Brunner Mond established its factory at Crescent Wharf in 1893 to manufacture soda and production continued there until 1912. With the enormous demand for munitions it was decided to use it for T.N.T. purification. Production was commenced in 1915 despite the danger to this densely populated district. The danger became a reality at 6.52pm on 19 January 1917 when a fire in the melt-pot room caused an explosion of 50 tons of T.N.T.

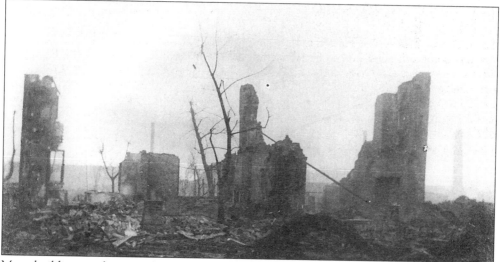

Many buildings in the immediate vicinity, including Venesta's plywood factory, the fire station opposite and several streets of houses were demolished in the Silvertown Explosion, which holds the record of being the largest explosion in London. Fires raged in the flour mills and on a ship in the Royal Victoria Dock. This photograph shows the effects of the explosion on the Silvertown Lubricants oil works at Minoco Wharf, which stood on a site adjacent to Brunner Mond's.

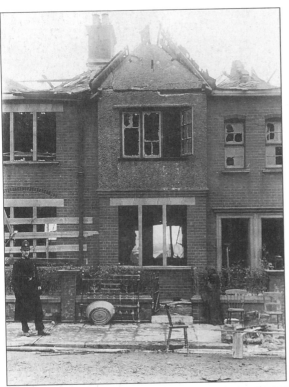

People all over London heard the bang and felt the blast which damaged over 60–70,000 properties, and saw a red glow in the sky that was visible for miles around. This photograph shows a policeman on duty outside the firemen's dwellings in Fort Street.

Several local organisations led by Canning Town Women's Settlement provided emergency relief to those who had been made homeless and West Ham Council opened a relief office at the Public Hall in Canning Town. Considering the force of the explosion and the nature of the district, casualties were remarkably few. Seventy-three people were killed and several hundred injured.

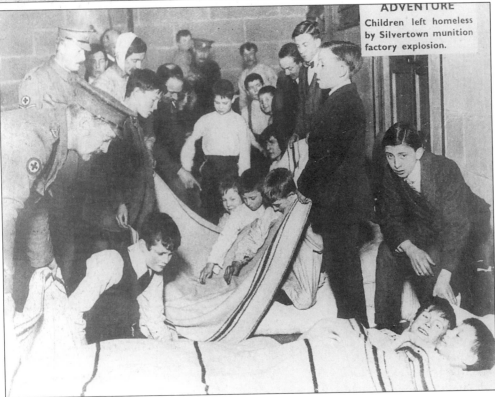

ADVENTURE
Children left homeless by Silvertown munition factory explosion.

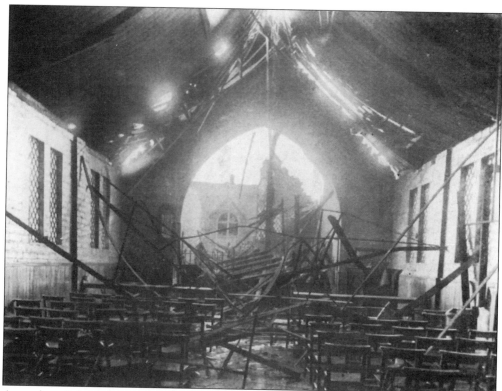

A number of children were enjoying a party at the Sunday School in St. Barnabas Church when the explosion occurred. The walls blew out and the roof caved in. A teacher, Norah Griffiths, ran to side of the hall, gathered the helpers and then held the roof up while the children got out unharmed.

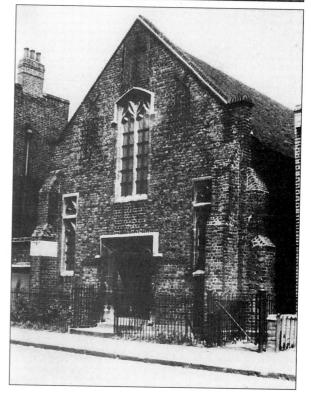

St. Barnabas Church was virtually destroyed by the Silvertown Explosion and a new memorial hall was built and opened in 1919. It subsequently became the nave of a new church with adjacent hall premises. The whole of it was consecrated in 1926 when St. Barnabas became a separate parish. This photograph was taken in 1959.

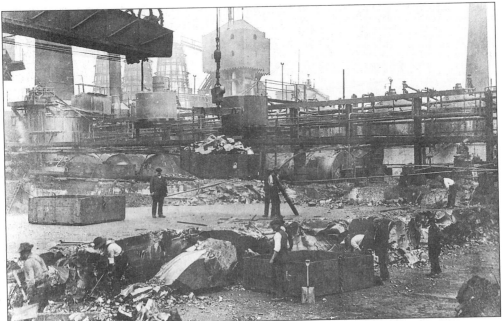

Burt, Boulton and Haywood at Prince Regent's Wharf made a range of products from the residue of the gas making process. There was large pitch lake at their works which in 1910 held about 10,000 tons of pitch and workers are seen here removing it. Creosote was produced there and thousands of railway sleepers, telegraph and telephone poles were treated each year.

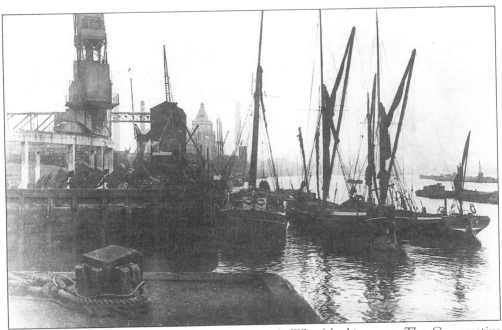

Thames Sailing Barges moored off Prince Regent's Wharf looking east. The Co-operative Wholesale Society's building is on the left.

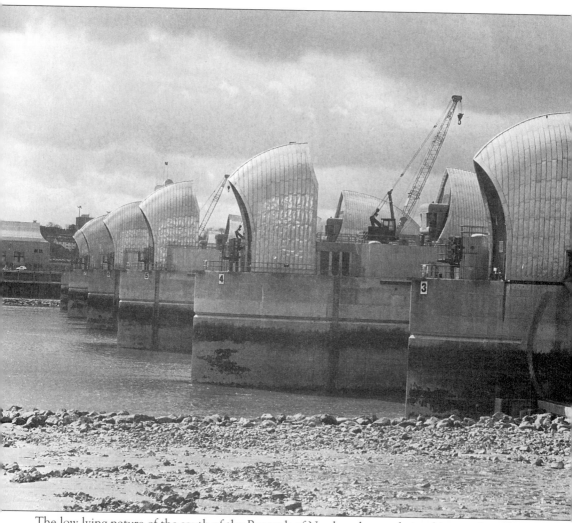

The low lying nature of the south of the Borough of Newham has made it subject to the effects of the Thames flooding. A number of sites and designs for a flood protection scheme were proposed following the disastrous floods in 1953. The site chosen for the Thames Barrier spans the river between Silvertown and Charlton. It consists of ten separate movable steel gates, each pivoting and supported between concrete piers which house the hydraulic machinery. The gates are raised in the event of a flood to hold back the tide. Built at a cost of £435 million it is the largest movable flood barrier in the world. It came into operation in 1982. This photograph was taken from the north bank on 23 March 1989.

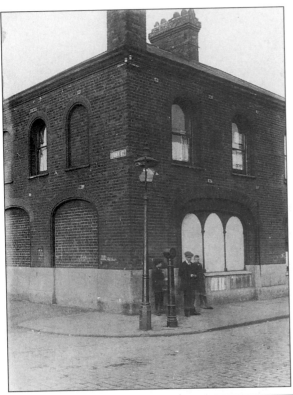

The first Silvertown Fire Station at 447 North Woolwich Road stood at the corner with Emma Street. It was replaced by a new building in Fort Street in 1914. A gas lamp and street fire alarm can be seen on the corner of the street taken in about 1920.

North Woolwich Road on 3 August 1961 looking east from the roof of the Union-Castle building. On the right are the extensive railway sidings , the remains of the Cooperative Wholesale's Society's factory and to the left in front of St. Mark's Church is Silvertown School in Oriental Road.

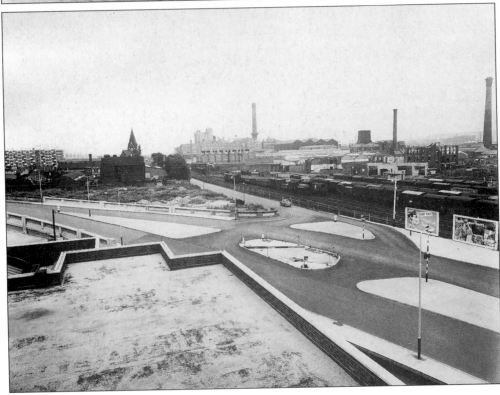

St. Marks Church was designed by S.S. Teulon and opened in 1862. Its stone work was blackened by the smoke and fumes from the surrounding factories and the railway locomotives which passed by. Seen here in 1971, the building closed in 1974 and was badly damaged by fire in 1981. Plans were put forward to restore the building and use it to house the Passmore Edwards Museum's Victorian collections.

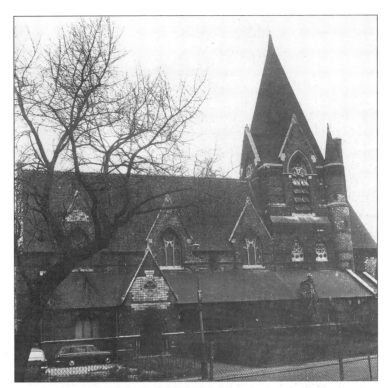

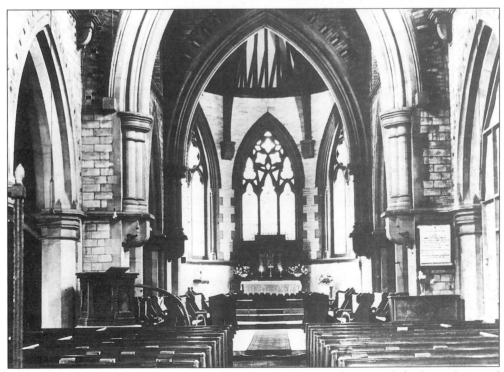

The interior of St. Mark's Church in 1957. The original hammerbeam roof which was destroyed in the fire in 1981 was reproduced when the building was restored.

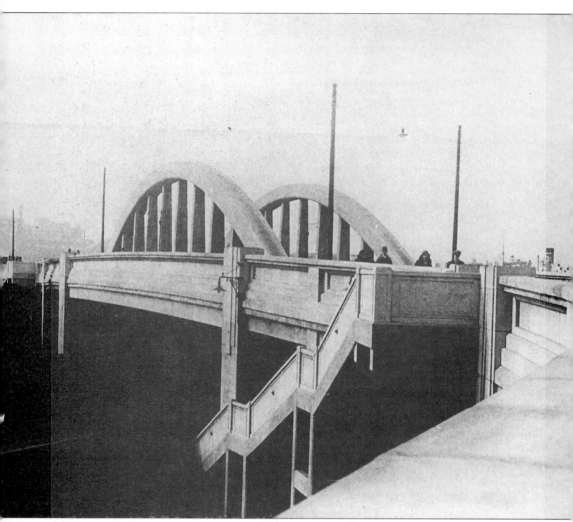

Silvertown By-Pass with its bow-string bridge was opened in 1935 to carry traffic over the roads and railways and avoid the delays which had previously occurred at the level crossings in the Connaught Road and emerging North Woolwich Railway. Due for demolition several years ago it still stands and has featured in a number of television advertisements in recent years.

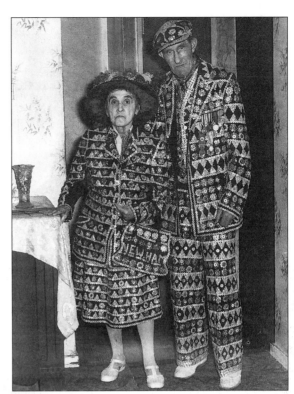

The Pearly King and Queen of Newham, William and Beatrice Davison, lived in a one-bedroom council flat in Camel Road when this photograph was taken in 1972.

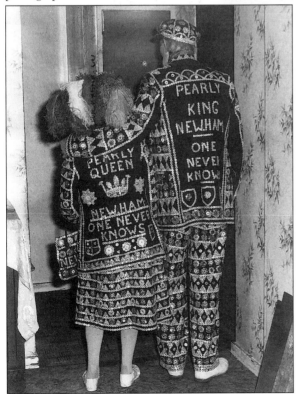

Bill had worked as a docker and Beatrice had been a domestic servant before she was married. Mr. Davison made all his own outfits, and also his wife's pearly dress and the cap and jacket for his dog, Rover.

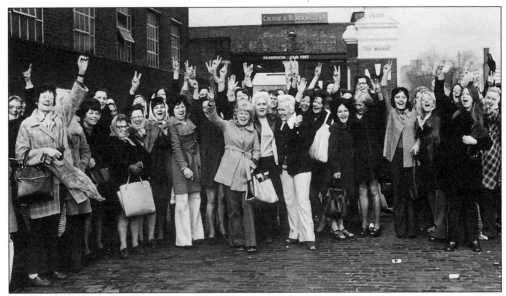

Workers at Crosse and Blackwell's factory in the 1970s. 'Branston' pickle was amongst the many products made there.

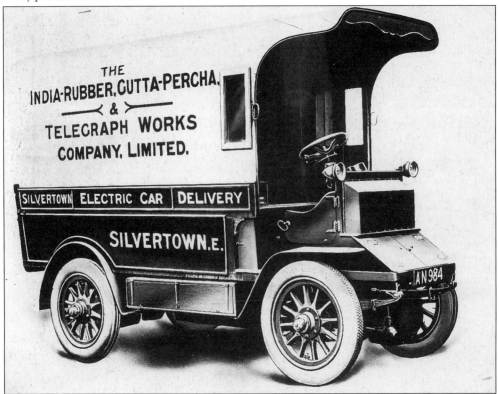

The India Rubber, Gutta Percha and Telegraph Works Company (which was known as 'The Silvertown Company') factory covered an area of over seventeen acres in 1920. A very wide range of products were made there including rubber belting and tyres, electrical machinery, submarine telegraph cables and golf balls.

90

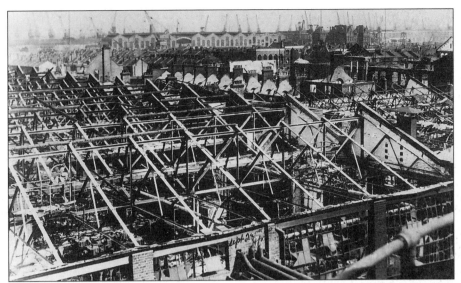

Bombs caused extensive damage to the Silvertown Rubber Works and the surrounding area. This elevated view, also taken on 23 September 1940, looks north towards the King George V Dock showing the houses near Albert Road and Drew Road School looming above them.

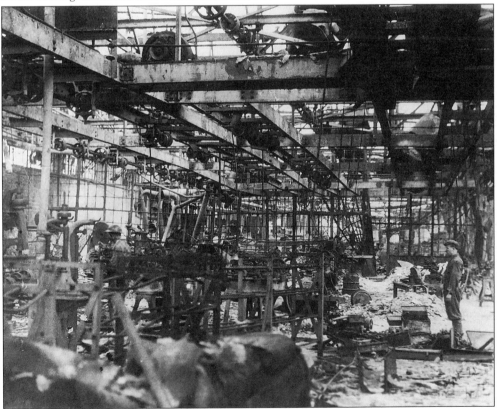

An interior photograph of the bomb-damaged machinery, taken on 23 September 1940. Despite the Blitz and the V1 and V2s local people continued to work at the local factories many of which had turned to making materials which could be used to fight the war.

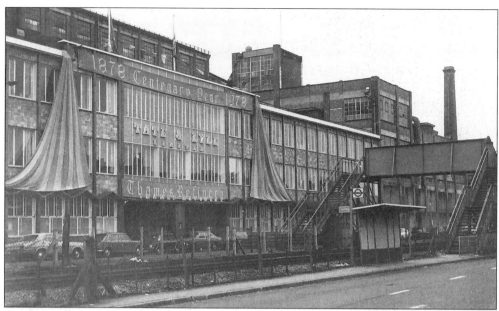

Henry Tate came to Silvertown in 1878 and established the Thames Refinery. He had the rights to a patent for manufacturing cube sugar, a form which came to dominate the market and caused loaf sugar to fall out of favour. The two separate firms of Tate's and Lyle's were merged in 1921. It is the area's largest employer and Thames Refinery is one of the major cane sugar refineries in Britain if not the world.

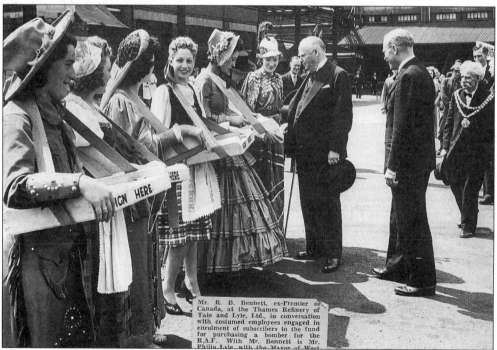

Mr. R. B. Bennett, ex-Premier of Canada, at the Thames Refinery of Tate and Lyle, Ltd., in conversation with costumed employees engaged in enrolment of subscribers to the fund for purchasing a bomber for the R.A.F. With Mr. Bennett is Mr. Philip Lyle with the Mayor of West

The ex-Premier of Canada, R.B. Bennett in conversation with Tate and Lyle employees who were engaged in July 1940 in collecting money for the purchase of a bomber for the R.A.F. With Mr. Bennett is Philip Lyle and the Mayor of West Ham, Thomas Wooder.

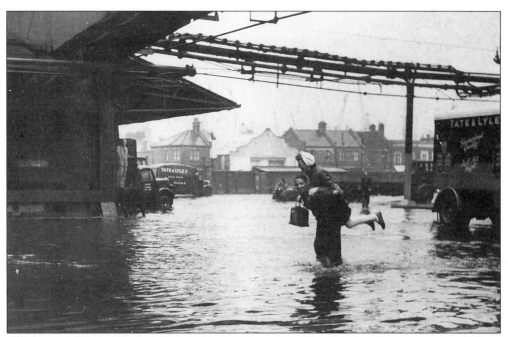

Flooding at Tate and Lyle's Thames Refinery in 1948. The former Albert Cinema in Albert Road can be seen in the background.

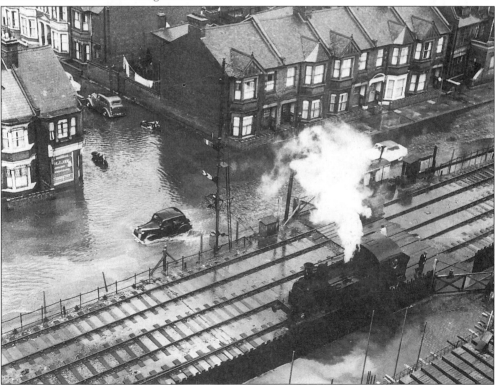

An elevated view of the storm flood from Tate and Lyle's Thames Refinery in August 1957. Looking north to Albert Road at the corner with Saville Road.

The surviving rows of Victorian terraced houses in Gray Street, Constance Street and Andrew Street were demolished under a clearance order which was agreed in 1956 and new flats and houses were built on the site.

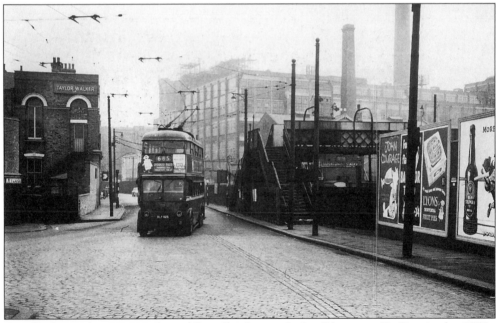

A trolleybus making its way from Albert Road towards the Silvertown By-Pass in the 1950s. Silvertown Station is on the right and the Railway Hotel, which is still known by many local people as 'Cundy's', after one its former landlords, is on the left.

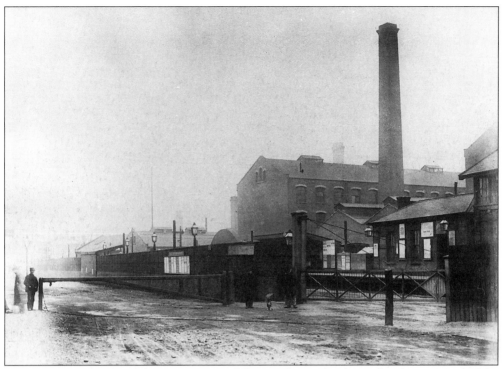

The North Woolwich Land Company owned the North Woolwich Road and eastern end of the Victoria Dock Road and charged tolls on vehicles using it at the toll gate seen here on the left near Silvertown Station in 1884. The gate was removed when the road was acquired by the West Ham Local Board of Health in 1886.

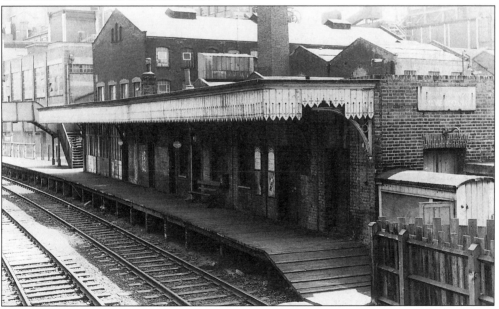

Silvertown Station was opened in 1863 to serve the district's growing industry and population. This photograph was taken in 1978. A new station, which was re-named Silvertown and London City Airport in 1989, was opened in the early 1990s.

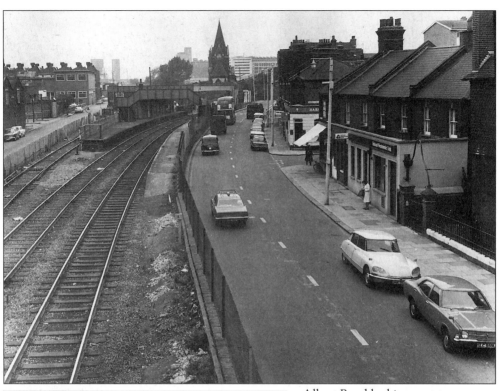

Albert Road looking west to Silvertown station and St. Mark's Church in 1975. Large numbers of German and Lithuanian immigrants settled in the streets off Albert Road during the nineteenth century. Many of them were employed as labourers in the sugar refineries or at Beckton Gasworks.

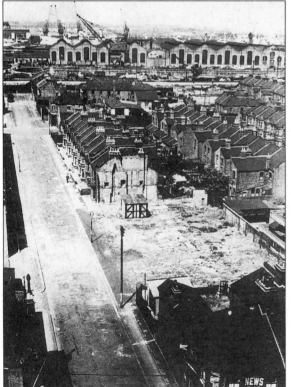

Looking north from the junction with Albert Road along Parker Street and towards the King George V Dock in about 1944.

Wythes Road in 1975. The Baptist church on the right side of the road which became a branch of West Ham Central Mission remained in use until 1968.

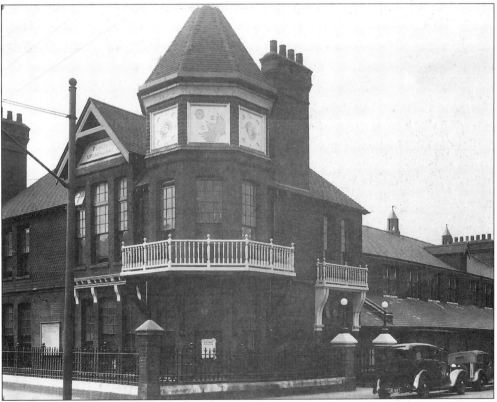

The Tate Institute in Albert Road was opened in 1887 by Henry Tate as an educational and recreational club for his employees. Closed in 1933, it was bought by West Ham Council and converted into a Public Library and Hall which opened in 1938. It was leased back to Tate and Lyle as a social club in 1961.

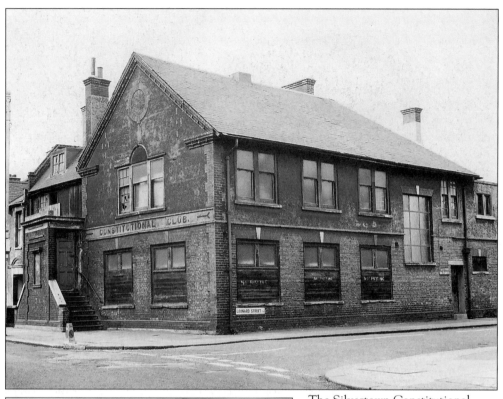

The Silvertown Constitutional Club in Albert Road was founded in 1892. It was a centre for Conservative Party activity in the area and was also used for dances and social activities. This photograph was taken in 1971.

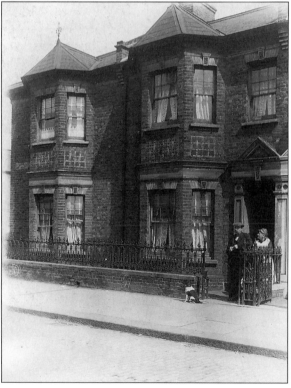

50 and 51 Albert Road in July 1922 (note the chalked numbers on the front walls). This was one of a series of photographs taken of Albert Road at the time.

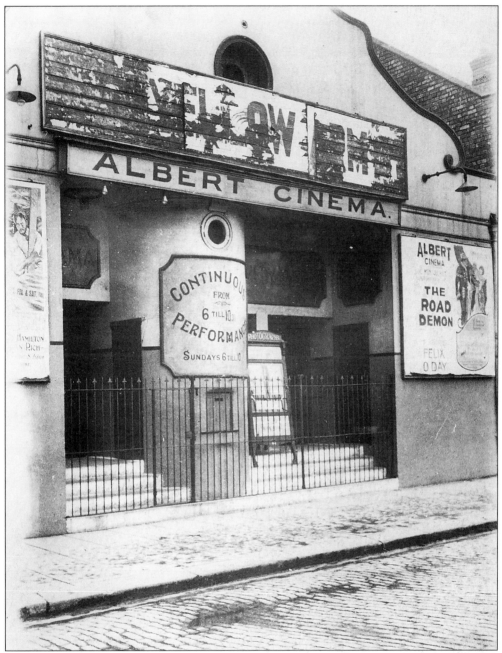

Albert Cinema at 60 Albert Road, seen here in 1922, was built in 1912 and run by W. & H. Sweetingham. Many of the children who went there bought a halfpenny carrot or some sweets from the shop next door, which they ate while watching the films. The cinema was closed before the Second World War.

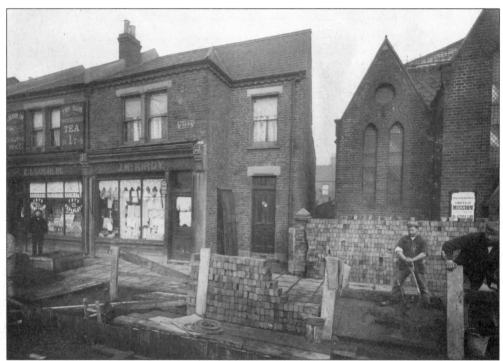

Men working on the sewers in Albert Road in 1901. At number 78 was Eugene Loughlin, grocer; at 79 James McKirdy, fancy draper, Silvertown Wesleyan Methodist Church is on the right.

Bailey Street looking north to the Royal Albert Dock. Bailey and nearby Wilton Street were demolished to make way for the construction of the King George Dock, on which work began in 1912.

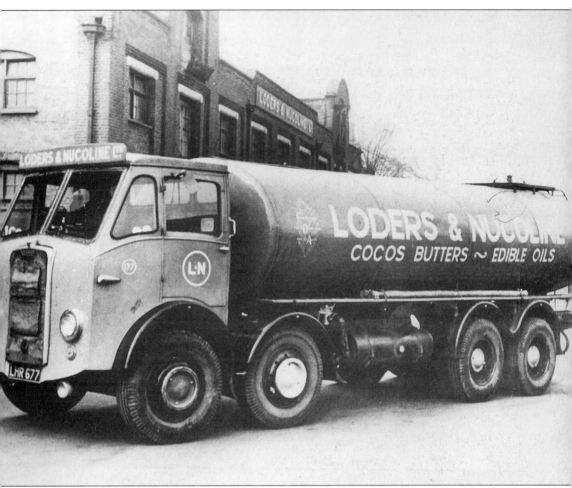

Loders and Nucoline established their factory at Cairn Mills in 1887. They procesed vegtable oils and fats which were used in products such as biscuits and confectionery.

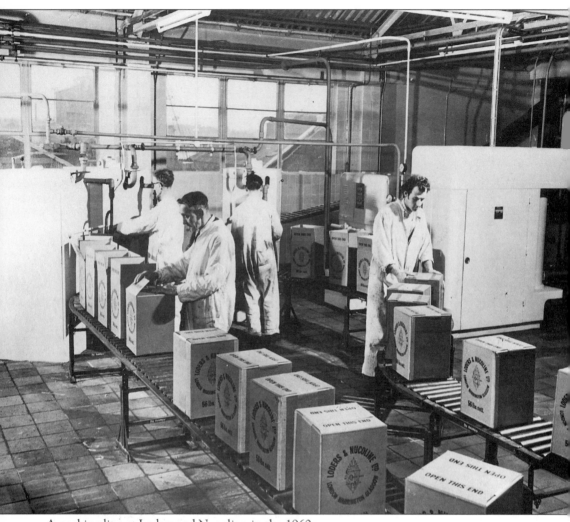

A packing line at Loders and Nucoline in the 1960s.

Five

North Woolwich

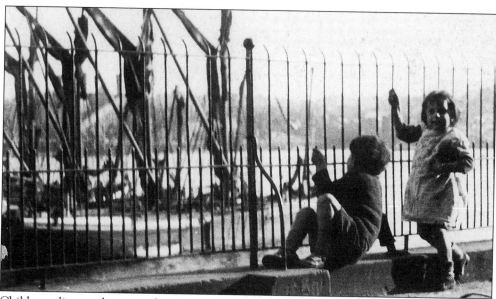

Children glimpse the ever changing scene on the river through the railings at the Royal Victoria Gardens Before North Woolwich was incorporated into the London Borough of Newham in 1965 it largely comprised of two detached parts of the Metropolitan Borough of Woolwich on the north side of the Thames. The administrative anomaly of 'Kent in Essex' which existed for nine hundred years, was most probably due to Hamon, the eleventh-century Sheriff of Kent, whose manorial land extended both sides of the Thames.

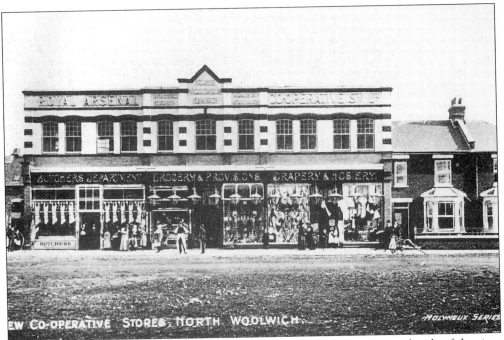

The Royal Arsenal Co-operative Society opened their only shop on the north side of the river in Kennard Street in 1905. This postcard view shows it before the First World War. It was closed in the late 1970s and houses now stand on the site.

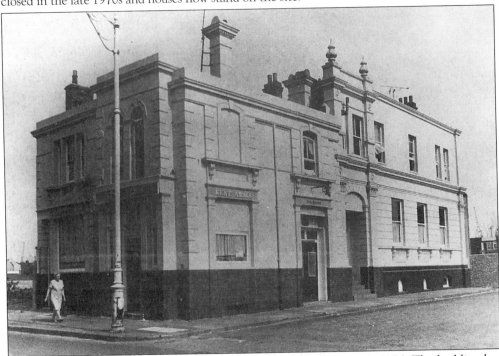

The Kent Arms, Albert Road, on the corner with Dockland Street in 1976. The building has been demolished and Kate's Place public house which takes its name from a former local street now stands on the site.

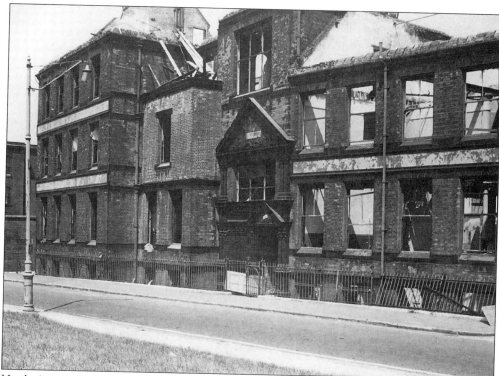

Henley's opened its electric cable works in 1859. This photograph shows its derelict building in 1976. British Telecom's London Teleport satellite station which opened in 1984 now stands on the site.

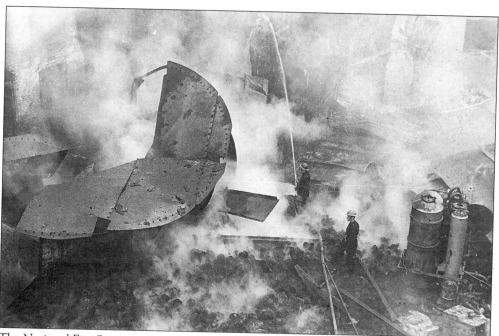

The National Fire Service putting out a fire at the Standard Telephones works on 20 July 1944 which had been caused when the building was hit by a V1 flying bomb.

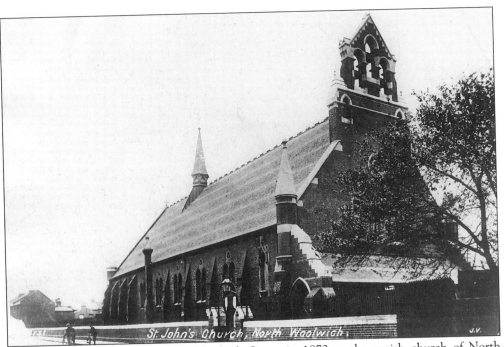

St John's Church was opened on Elizabeth Street in 1872 as the parish church of North Woolwich. It was destroyed by bombs and fire on the first day of the Blitz, 7 September 1940.

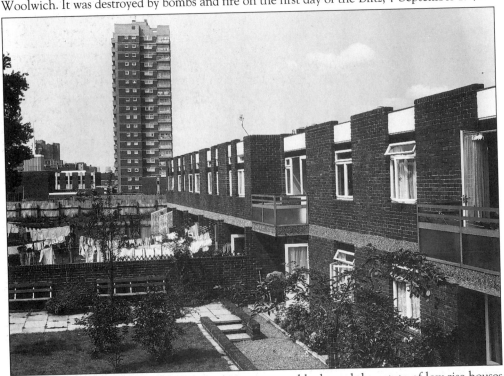

The Dunedin, Queensland and Westland House tower blocks and the estate of low rise houses to the west of Pier Road were developed by the Greater London Council in the 1960s. The new St John's Church in Albert Road, which can be seen on the left, was opened in 1968.

Pier Road and the streets to the east were redeveloped by East Ham Council and the housing scheme opened in 1965. The blocks of flats—Shaw, Albion, Brocklebank and Glen House were named after shipping companies associated with the Royal Docks.

Pier Parade looking towards Woodman Street in the 1960s.

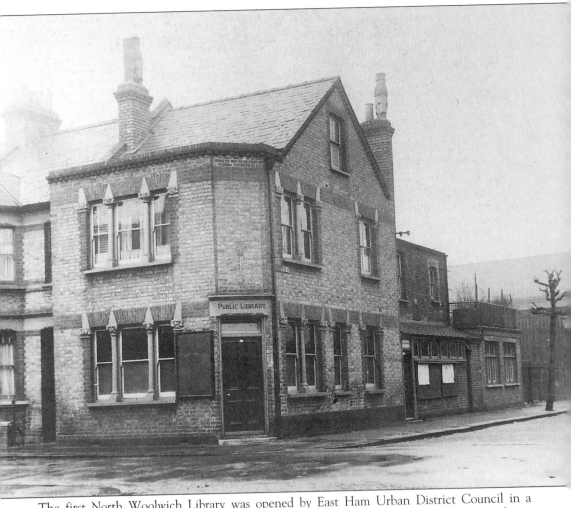

The first North Woolwich Library was opened by East Ham Urban District Council in a converted house in Elizabeth Street in 1896. The part-time librarian earned the munificent salary of £30 per year.

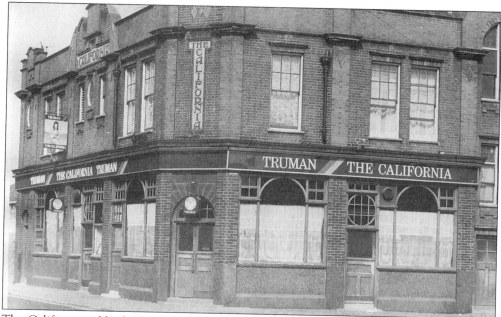

The California public house in Albert Road in 1976. The building was designed in 1914 by Robert Banks-Martin in 1914 who was also responsible for East Ham's War Memorial which was unveiled in Central Park in 1921. He was an East Ham Councillor and Mayor from 1914 to 1918.

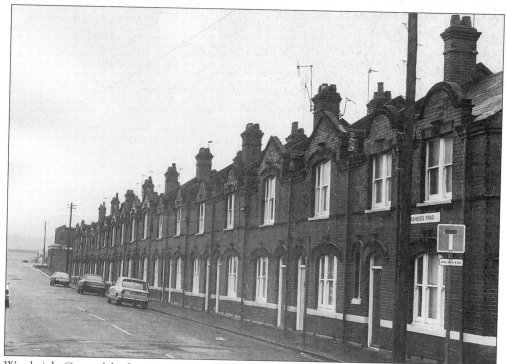

Woolwich Council built a number of 'Working Class Dwellings' in Barge House Road and Woolwich Manor Way in 1901. Some of those in Barge House Road are shown in this photograph taken in 1975.

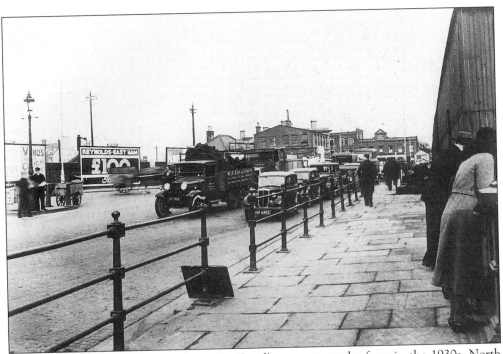

Traffic waiting in Stanley Road (now Pier Road) to go on to the ferry in the 1930s. North Woolwich Station and goods yard can be seen near the centre of the photograph and the Royal Pavilion public house to the right.

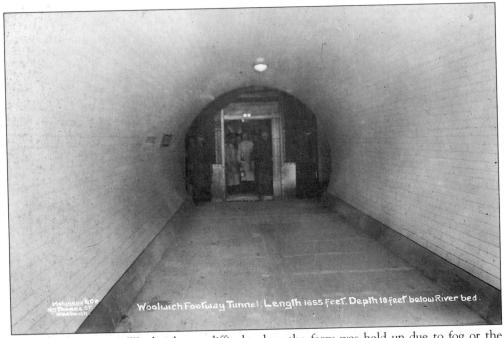

Woolwich Footway Tunnel. Length 1655 feet. Depth 10 feet below River bed.

Crossing the river at Woolwich was difficult when the ferry was held up due to fog or the movement of shipping and people were delayed on their way to work. The London County Council opened the Woolwich Foot Tunnel in 1912 as an alternative route.

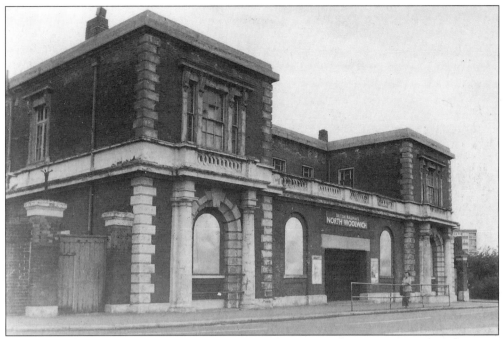

North Woolwich Station was built in 1854 to serve the docks, industry, local population and visitors to North Woolwich Gardens. It was closed in 1970 and is seen here in 1976. The building has been restored and opened in 1984 as a museum which displays material relating to the Great Eastern Railway.

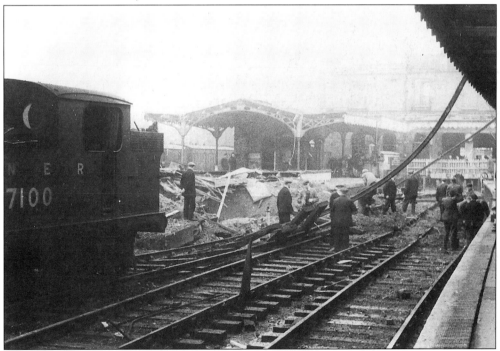

North Woolwich Station was badly damaged by bombing on 7 September 1940. The canopy collapsed onto trains standing in the platforms and the station building was gutted.

A postcard of the Royal Victoria Gardens in the early 1900s. Opened in the 1850s as the Royal Pavilion pleasure gardens, its attractions included dancing, music hall acts, a maze, balloon ascents and firework displays. Their popularity had declined by the 1880s and funds were raised to acquire the land for a public park. They were handed over to the London County Council, renamed the Royal Victoria Gardens, and opened in 1890.

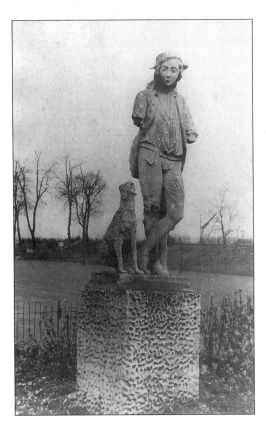

The damaged statue of a shepherd with his dog in the Royal Victoria Gardens in about 1958. A survival probably from the period when the park was a pleasure garden. The shepherd and shepherdess statues can be seen near the entrance in the postcard above.

A drinking fountain in the Royal Victoria Gardens in about 1958

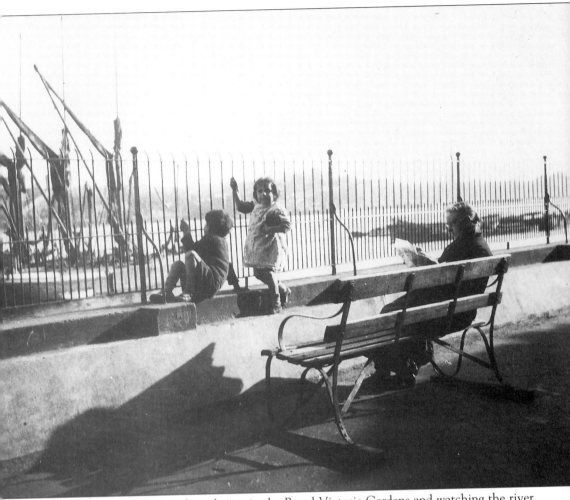

Many children spent their days playing in the Royal Victoria Gardens and watching the river traffic from the riverside esplanade. This view taken on 30 May 1934 is now obscured by a concrete wall which was built to protect the area from flooding when the Thames Barrier is operated.

Six

On the River

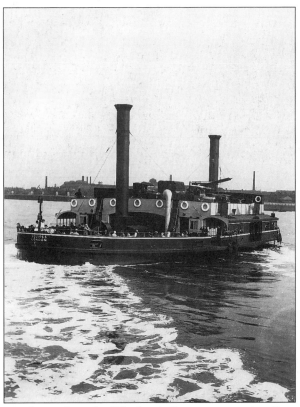

Vessels of all shapes and sizes from the Woolwich Ferry, ocean going liners, dredgers, colliers, barges and tugs could be seen on the river, each served a particular purpose in the Port and were crewed by skilled people who understood the ways of the winds and the tides.

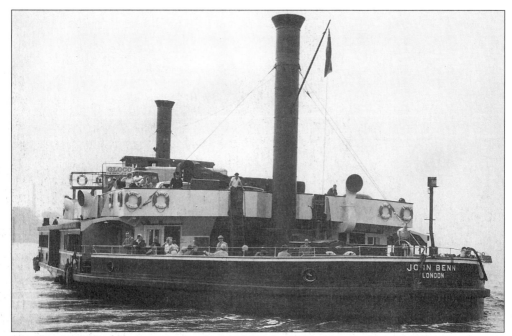

The Woolwich Free Ferry was opened on 23 March 1889 by the newly formed London County Council. Two side loading paddle steamers, the *Duncan* and *Gordon* initially provided the service with a third boat, the *Hutton*, added in 1893. These were replaced by the *Squires* and *Gordon* in 1922 and *John Benn* and *Will Crooks* in 1930.

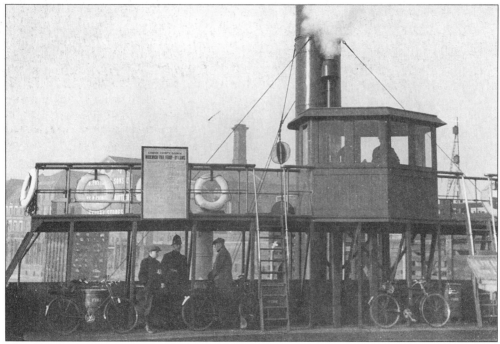

The Captain controlled the operation of the Ferry from the bridge. From here he communicated with the engine room by telegraphs and steered the vessel through the busy river traffic.

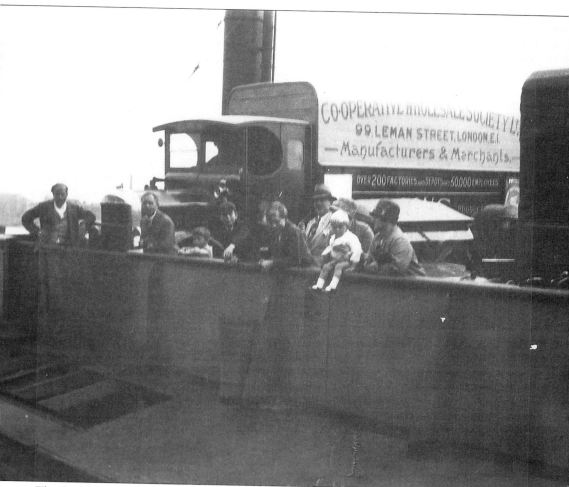

The ferries were popular attraction for children who enjoyed going to and fro across the river especially during the weekends and holidays. Many of them tried to stay on as long as possible by evading the eye of the crew. Another attraction of the Ferry was a visit to the engine room where they could see the gleaming steam engines thudding up and down as they drove the paddle wheels.

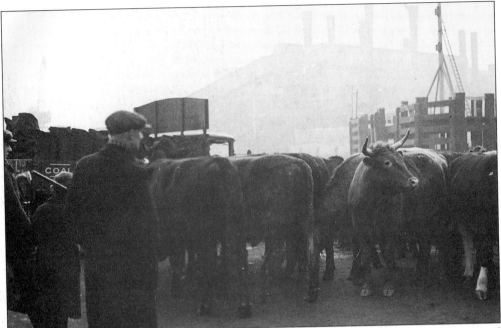

Herds of cattle were regularly transported on the Ferry from North Woolwich to the Royal Arsenal Cooperative Society's abattoir at Abbey Wood. This photograph and the one below were taken by George Taylor in the 1930s.

Horses on the Ferry.

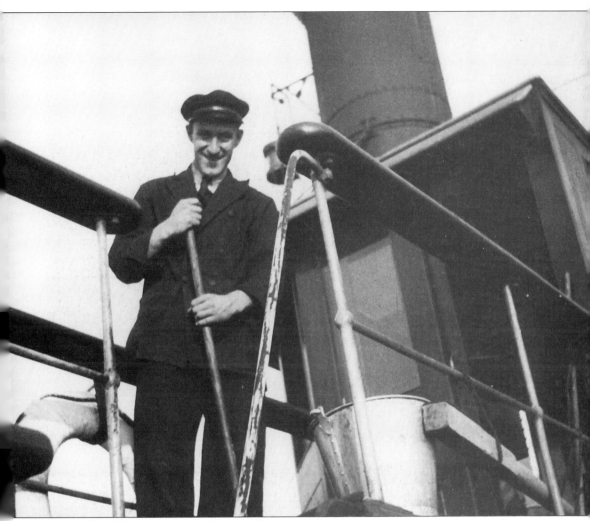

A member of the Ferry's crew cleaning the bridge.

No longer adequate for the larger vehicles the paddle steamers were superseded in 1963 by three new end-loading diesel-powered boats *Ernest Bevin*, *John Burns* and *James Newman*. They functioned, like their predecessors as side-loaders, until the new terminals and approach roads were completed in 1966. This photograph was taken on 25 May 1967.

The *James Newman* taken on the same day, looking north. By January 1989 the three boats, had ferried 26 million cars and lorries on over a million crossings.

P. &O. Ferries Jetfoil passing Woolwich Ferry in 1978.

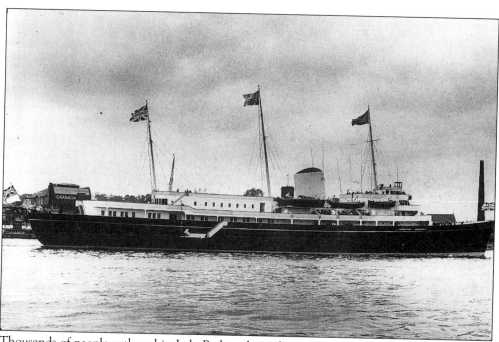

Thousands of people gathered in Lyle Park and at other vantage points along the river on 15 May 1954 to glimpse the homecoming from their first world tour of Queen Elizabeth and Prince Philip on the Royal Yacht *Britannia*. It seen is seen here passing North Woolwich pier.

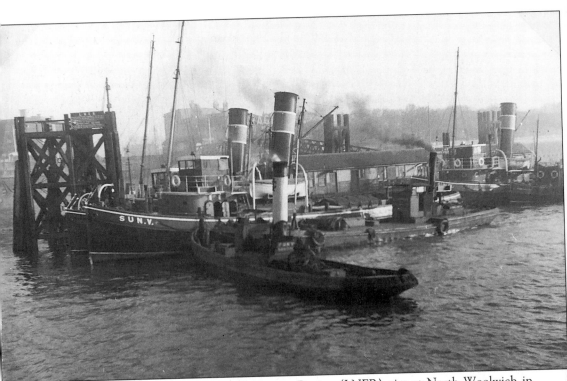

Tugs moored at the London and North Eastern Region (LNER) pier at North Woolwich in 1934. The pier was used by the 'Eagle' river steamboats on their trips from London to Clacton, Southend, and Margate.

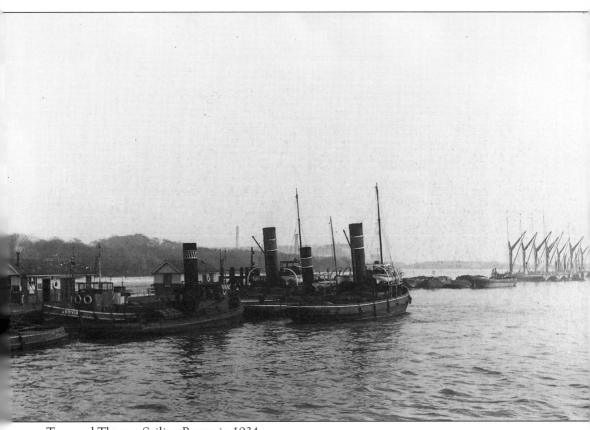

Tugs and Thames Sailing Barges in 1934.

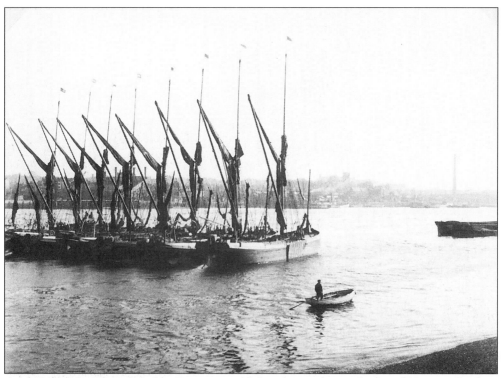

A number of the Thames Sailing Barges are seen here moored near the Royal Victoria Gardens awaiting orders for work, which was often hard to come by in the 1930s. This photograph was taken on 30 May 1934.

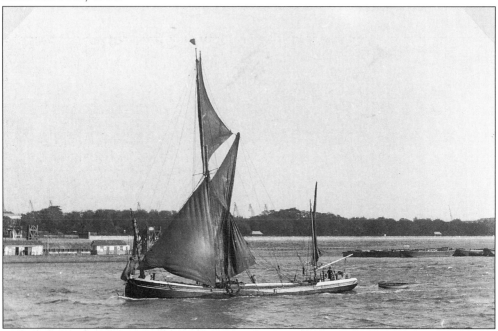

A Thames Sailing Barge passing the Royal Victoria Gardens in 1934. These vessels carried all manner of cargoes from hay, bricks, cement and manure.

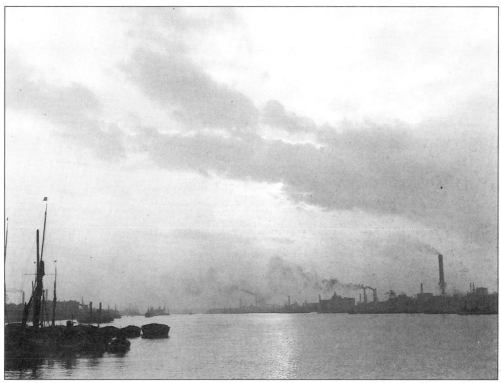

Evening on the river. Looking west from the Woolwich Ferry to the smoking chimney stacks in Silvertown in 1934.

Tugs moored in the river off North Woolwich in 1934.

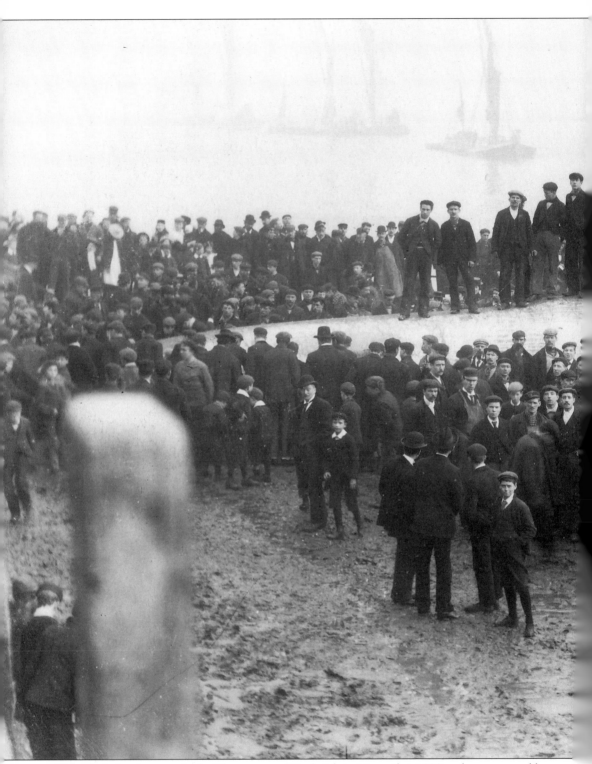

This whale lost her way in the Thames near Woolwich in November 1899 and was rammed by tugs and attacked with hatchets and crowbars until she was killed. The carcase, which measured

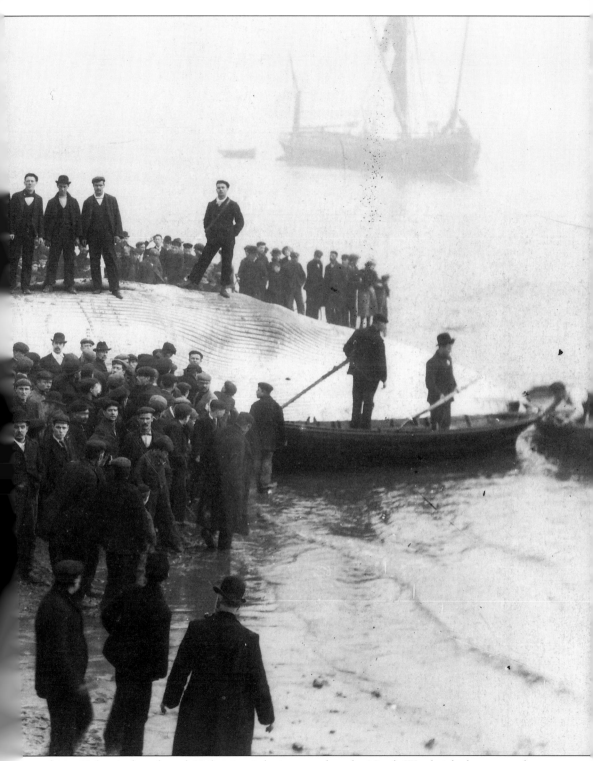

about 66 feet in length and 33 feet in girth was towed to the North Woolwich shore near the Royal Victoria Gardens where hundreds came to see it and hack off souvenir pieces.

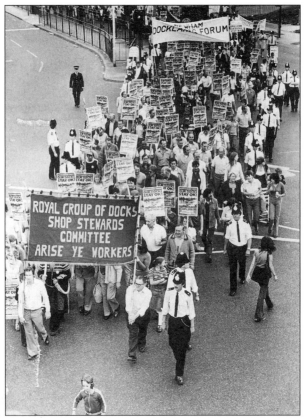

London's Docks were rundown and closed from the late 1960s, and thousands of people lost their jobs. The Royal Docks closed in 1981, despite widespread opposition, including this march on 15 July 1978. With the loss of the associated industries living conditions in the area deteriorated markedly and it soon became derelict.

Acknowledgements

Very special thanks to Rich Gerard, Dick Rowell, Frank Sainsbury, Reva Stanton and George Taylor, for sharing their memories with me and for their encouragement and support.

Bob Aspinall, Museum in Docklands, PLA Collection; Grace Bailey; Robert Barltrop; Mary Bradley; Danny Budzak; Jill Davies; Cyril Daynes; Helen Dowling, East Ham Reference Library—Historic Commercial Vehicle Collection; Ian Dowling; Bill England; Nick Harris, The Chalford Publishing Company Ltd; Colin Marchant; Wendy Neal; Sajida Raja; Winston Ramsay, Plaistow Press; Stephen Ramshaw; Eddie Richards, London Gas Museum; Don Rowan and Bill Rusby, Tate and Lyle Archives; Dorcas Sanders; *Socialist Worker*; Bill Storey; *Stratford Express*; Terry Turbin, North Woolwich Old Station Museum; Bill Walsh; Julian Watson, Greenwich Local History Library.